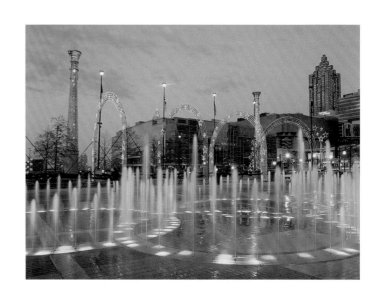

ATLANTA

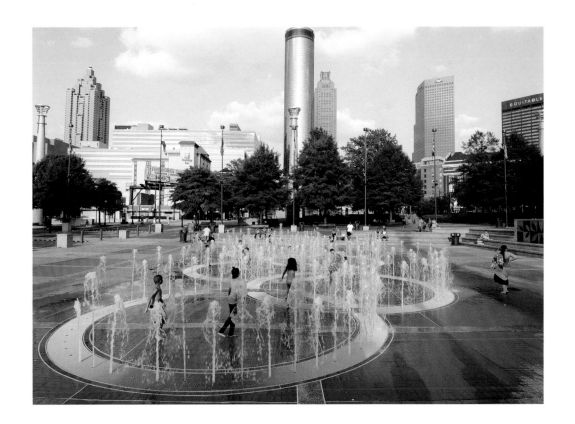

AMERICA SERIES

Text by Tanya Lloyd Kyi
Edited by Elaine Jones
Photo editing by Tanya Lloyd Kyi
Proofread by Lisa Collins
Cover and interior design by Steve Penner
Interior layout by Graham Sheard

Printed and bound in Canada.

Library of Congress Control Number: 2012945027
ISBN: 978-1-55285-357-3

For more information on the America Series titles, please visit Midpoint Trade Books at www.midpointtrade.com.

A city well-versed in the art of reincarnation, the Atlanta of today bears little resemblance to the settlement born more than 150 years ago. Terminus, named for its position on the Western and Atlantic Railroad, began as a community of laborers and saloons. Soon, however, citizens built homes, a post office and lumber mill opened, and stores lined the tiny downtown. Terminus seemed a poor name for this burgeoning community. Reborn as Marthasville in honor of Martha Atalanta Lumpkin, daughter of a former governor, it was renamed again in 1845, this time to Atlanta.

When the Civil War broke out less than two decades later, Atlanta was a thriving city, home to 9,000 people, and constantly expanding as new railway lines appeared. As the supply center for the Confederate army, it became the perfect target for Union forces. In 1864, General William T. Sherman marched into town and burned most of Atlanta to the ground.

Another reincarnation was required, and residents began successfully rebuilding. In the years after the war, almost 20,000 new citizens arrived. Atlanta's business world flourished. Skyscrapers rose and Fortune 500 companies started to erect their corporate headquarters there. From Atlanta, Coca-Cola began its race for international markets. CNN broadcast news across the nation and Atlanta became home to banks, airlines, and communications companies.

As cameras zoomed in on the 1996 Summer Olympics, Atlanta was officially introduced to the world. A television audience of more than 1 billion were given their first glimpse of the city as they watched the events staged in glistening new facilities. Just as southern belles are introduced to society with a formal ball, the spectacle of the Olympics seemed an apt occasion for the city's debut. Since then, Atlanta has become an international tourist destination, offering unique attractions and the famed hospitality of the South.

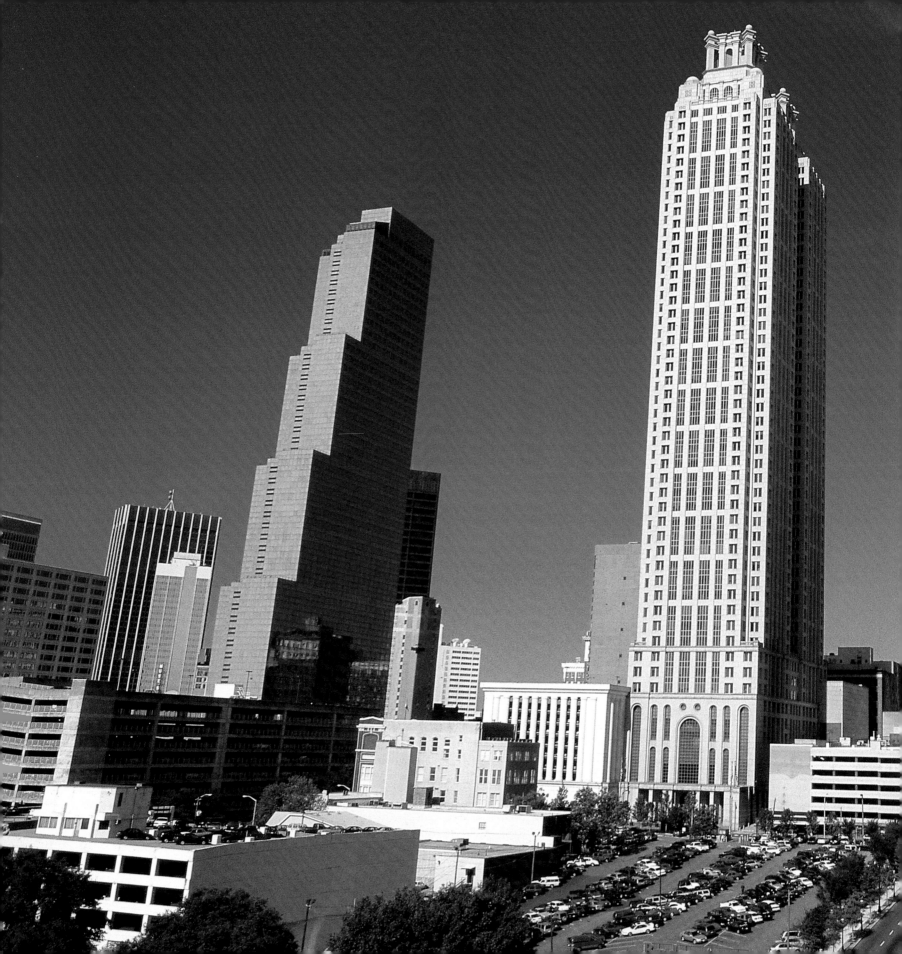

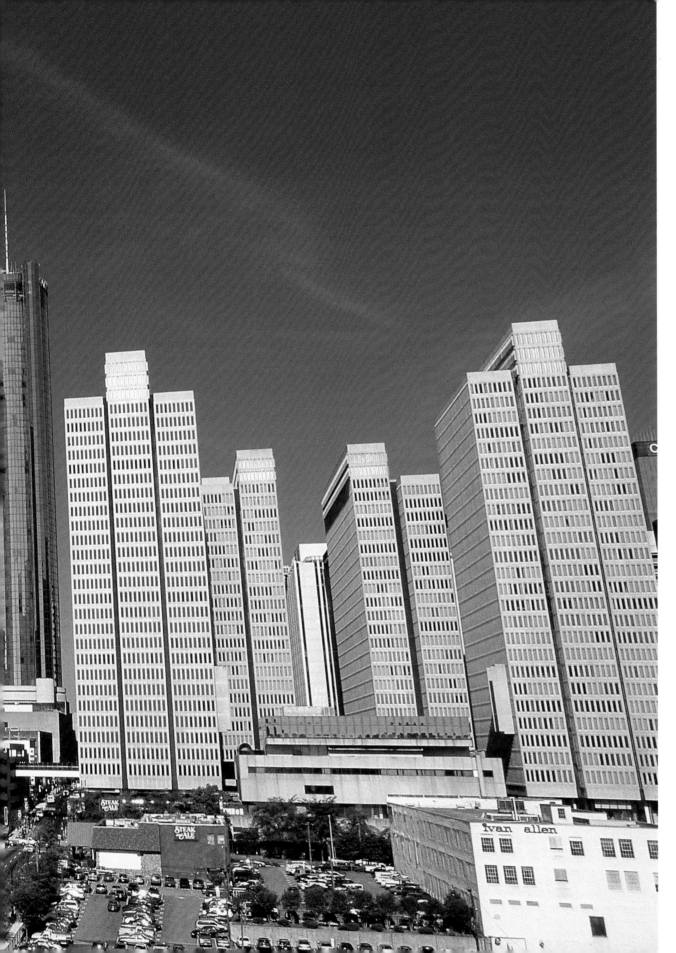

Atlanta was a stronghold of the Confederacy during the American Civil War. When Union forces under General William T. Sherman arrived in 1864, they burned much of the city. Thus, while other cities such as Savannah proudly display many heritage sights and buildings, most of Atlanta's streets were reborn after the 1860s.

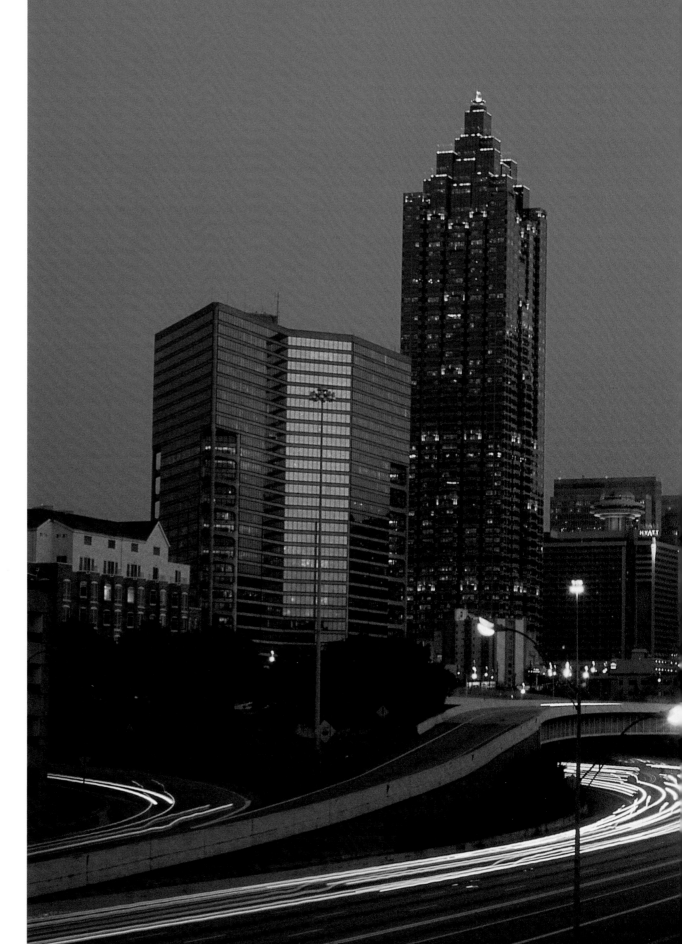

The corporate center of
southeastern America,
Atlanta is home to the
head offices of corpora-
tions such as Coca-Cola,
UPS, Home Depot, and
Delta Air Lines. The city
is also a destination for
sports fans, shoppers,
and arts enthusiasts.

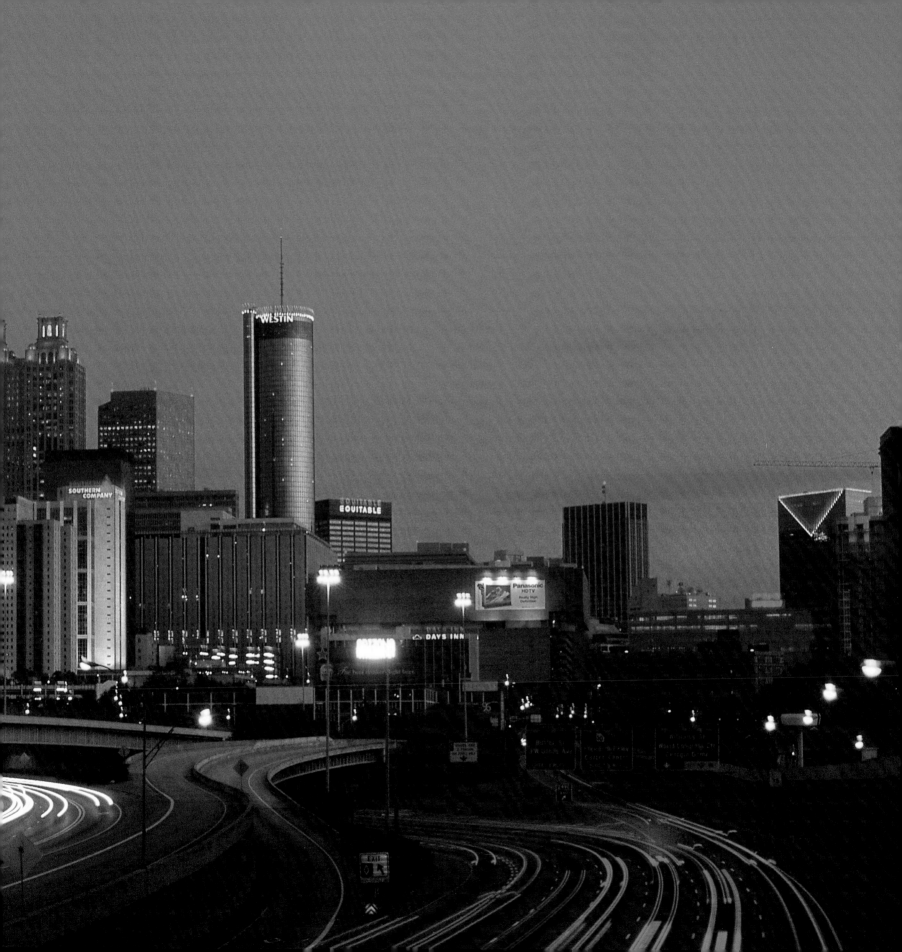

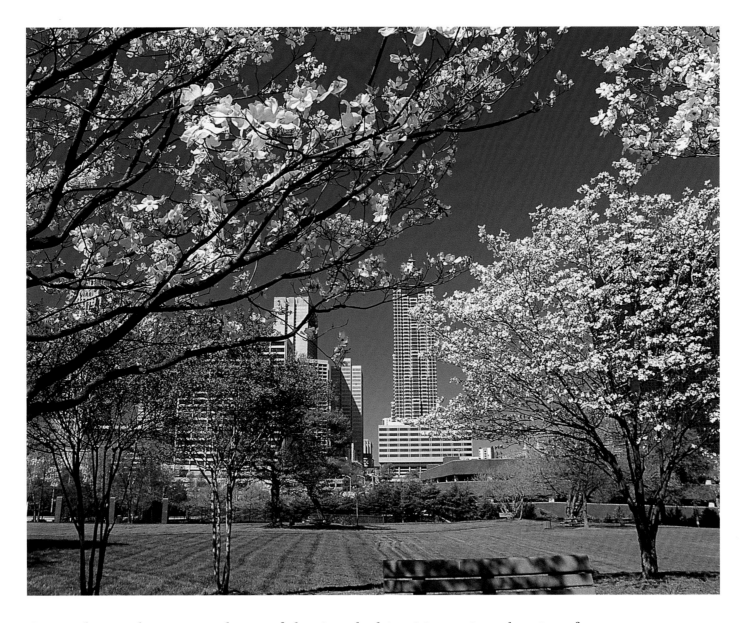

Situated near the eastern slopes of the Appalachian Mountains, the city of Atlanta enjoys four distinct seasons. The city's famous dogwoods are a celebratory sign of spring each year.

In 1936, department-store owner Walter Rich founded the Atlanta Dogwood Festival. His vision of a springtime pilgrimage to Atlanta has been realized every year since. The festival includes an artists' market, outdoor concerts, hot-air balloon rides, and more.

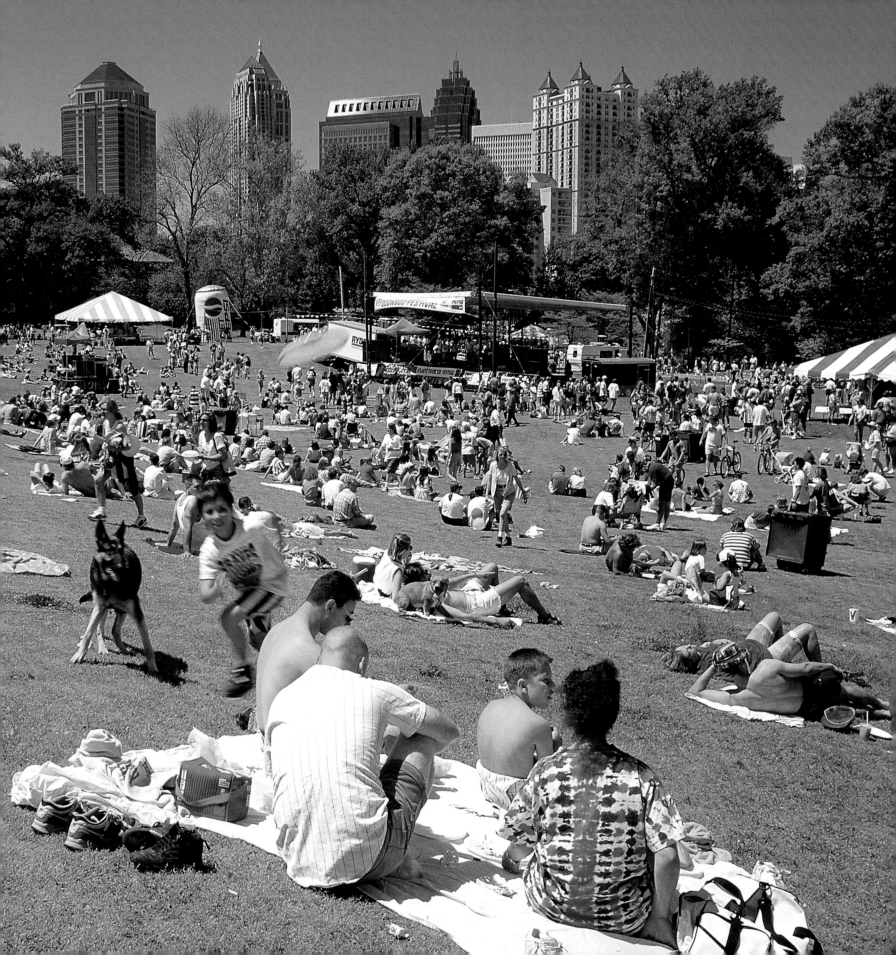

Robert W. Woodruff Park is named for the man who took control of the Coca-Cola company in 1923 and transformed it into an international giant. This downtown park is a welcome respite for workers and an occasional venue for outdoor concerts.

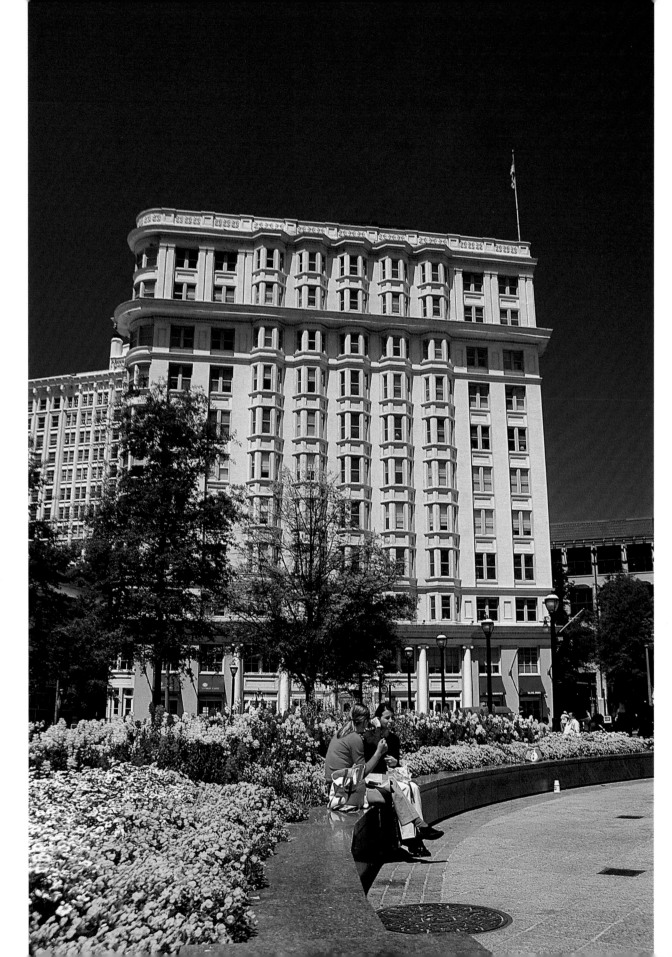

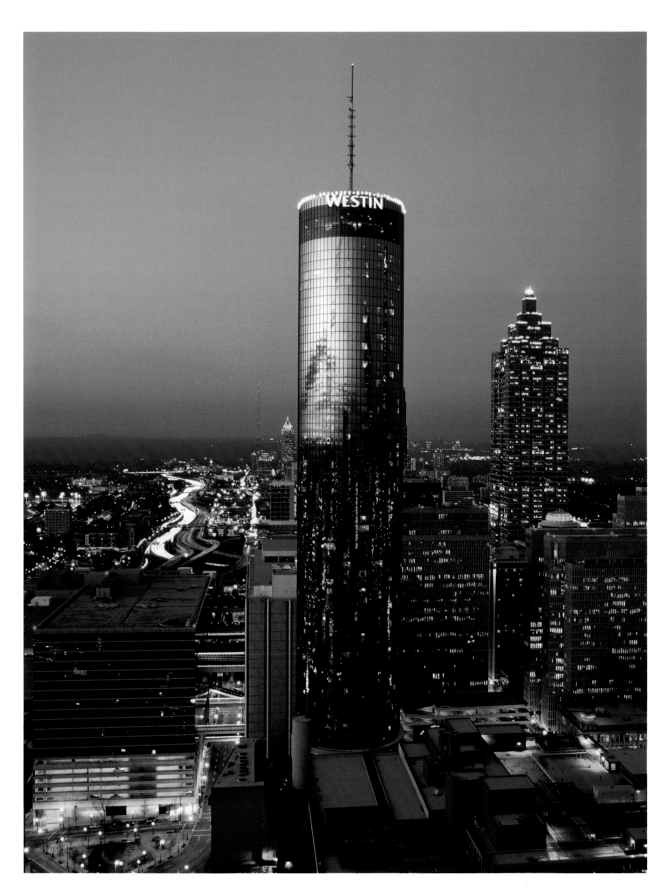

At the Westin Peachtree Plaza Hotel glass elevators whisk guests up 73 floors to the Sun Dial, a revolving restaurant that offers panoramic views of Atlanta.

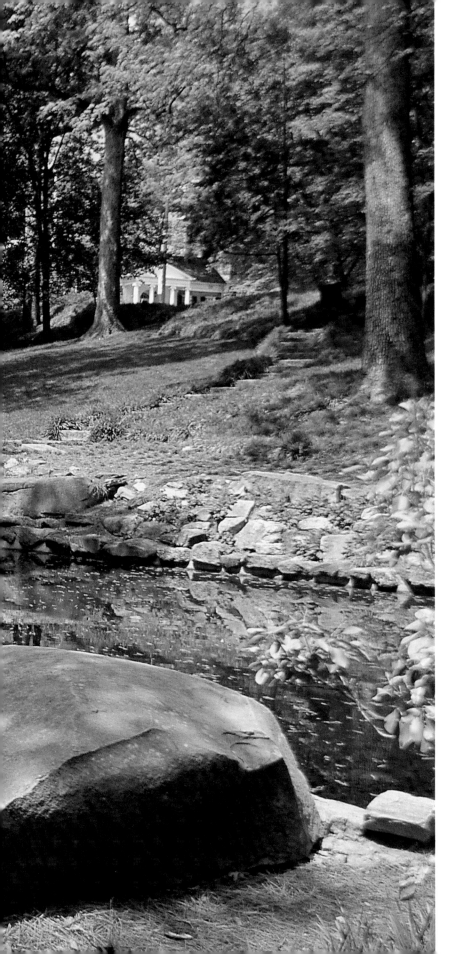

The population of Atlanta has swelled from 2,233,000 in 1980 to more than 4 million today. As the city expanded, city government and non-profit organizations worked to ensure parks, playgrounds, and green spaces were preserved. Today, the PATH Foundation, is helping create a city-wide network of recreational trails.

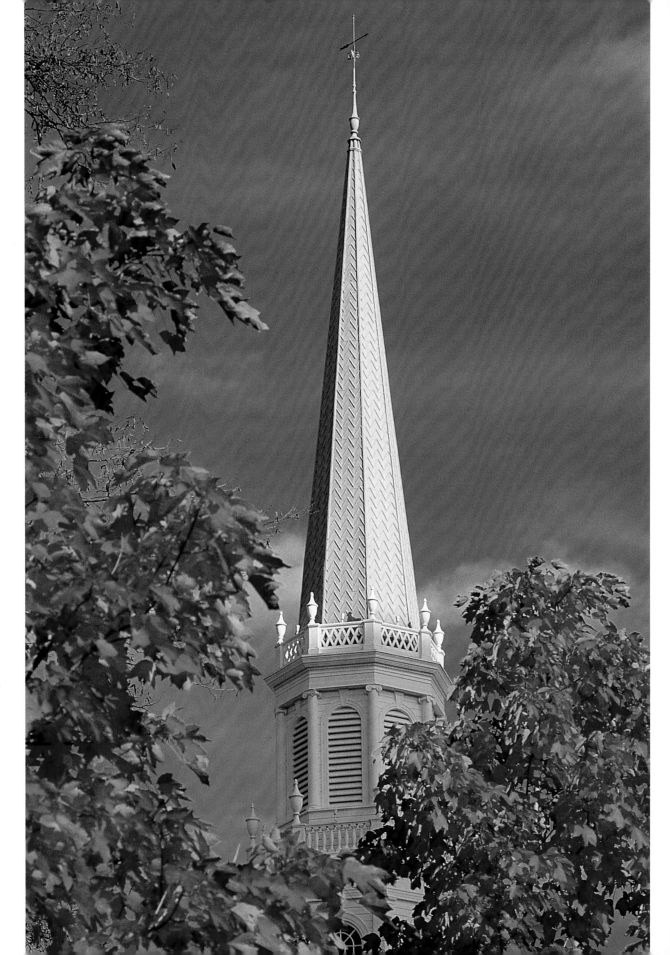

Second-Ponce de Leon
Baptist Church was
born in 1932, in the
midst of the Depression,
with the merger of two
struggling congregations
—Ponce de Leon Baptist
Church and Second
Baptist. The new parish
thrived, and the pictur-
esque sanctuary with its
recognizable steeple was
completed in 1937.

16

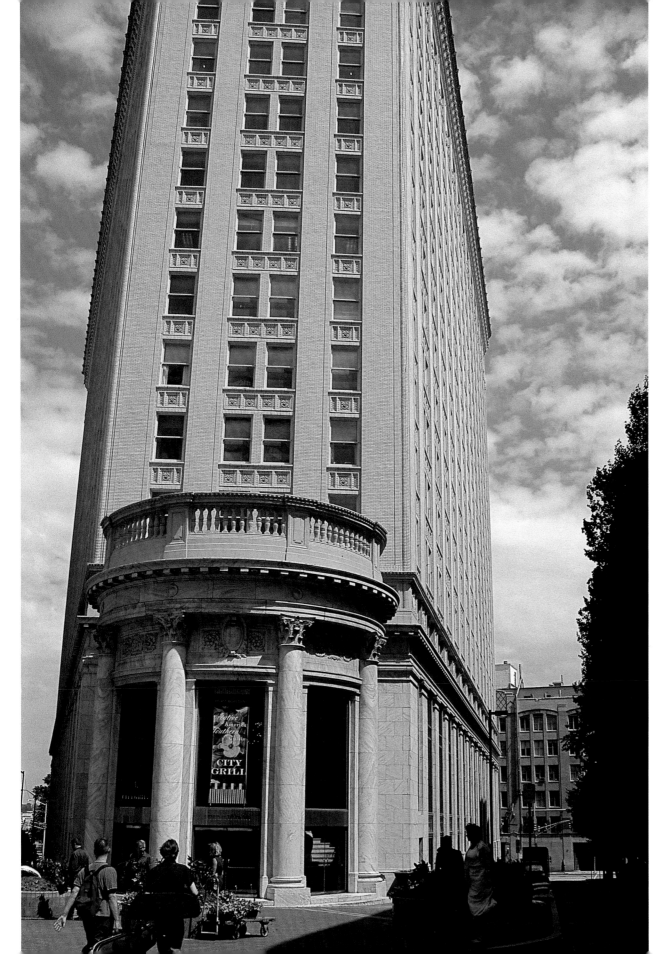

In 1912, businessman and land developer Joel Hurt constructed the Hurt Building, one of Atlanta's first skyscrapers. Like many towers of its time, it comprises three parts: a four-story base, a thirteen-story shaft, and a capital, or decorative cornice. In this case, the cornice is formed of layers of ornate molding and a rounded arch and can be clearly appreciated from the street.

17

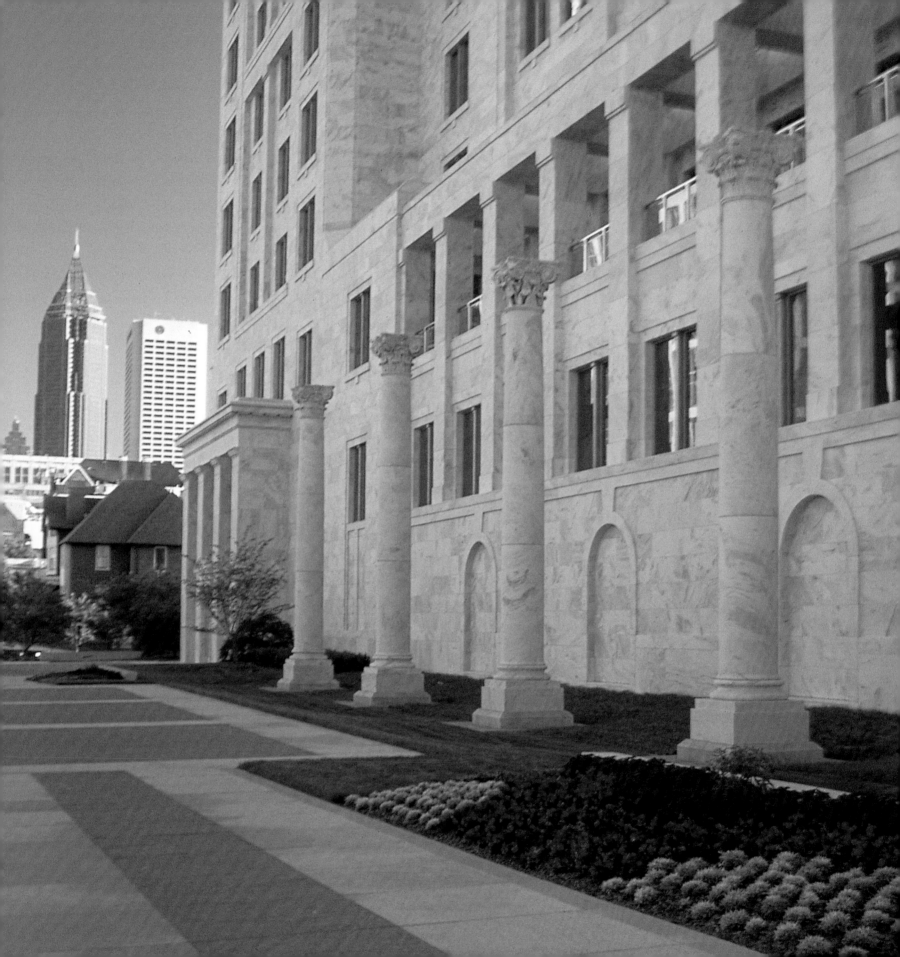

One of twelve such
institutions across the
country, the Federal
Reserve Bank of
Atlanta helps to forge
the nation's monetary
policies as well as
overseeing and regulat-
ing banks throughout
the southern states.
The Visitors Center
and Monetary Museum
houses exhibits about
the history of money and
the American economy.

A skywalk offers
pedestrians an easy
route through down-
town. Atlanta's center
is a hive of activity. The
city is home to twelve
Fortune 500 companies,
the fourth-highest con-
centration in America.
The last decade has
also brought residential
growth, with hundreds
of new condominiums
and apartments developed
in the downtown core.

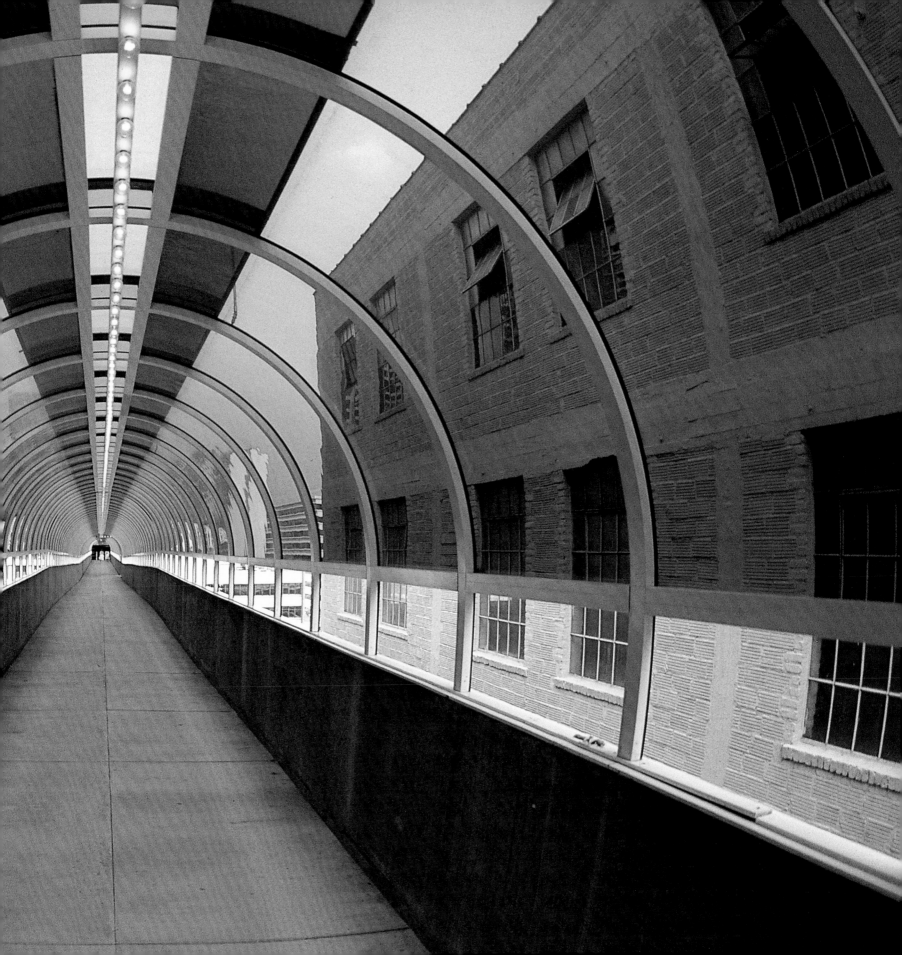

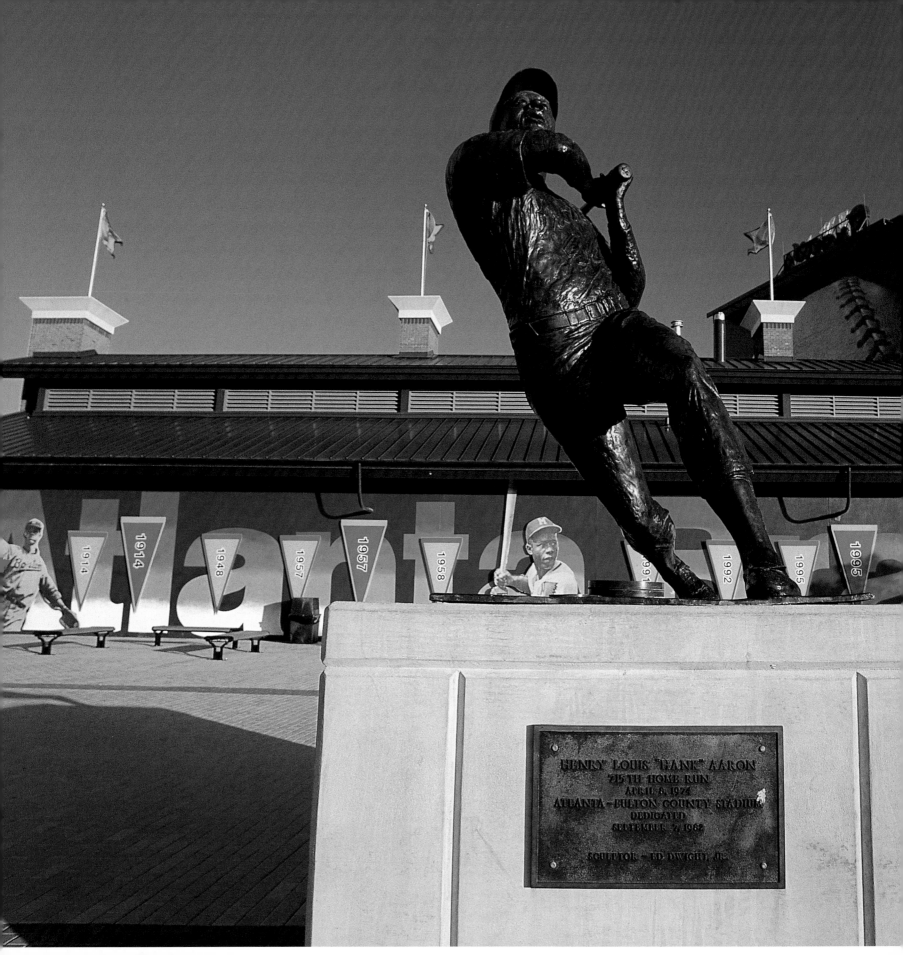

Although the action and excitement of the 1996 Olympic Games have faded, reminders of the event can still be seen in parks, sports venues, and art displays across the city.

Home to the Atlanta Braves, Turner Field is one of the most technologically advanced of America's ballparks. Five hundred televisions and two video boards allow spectators a detailed view of the action, while games pavilions, a hall of fame, and concessions await outside.

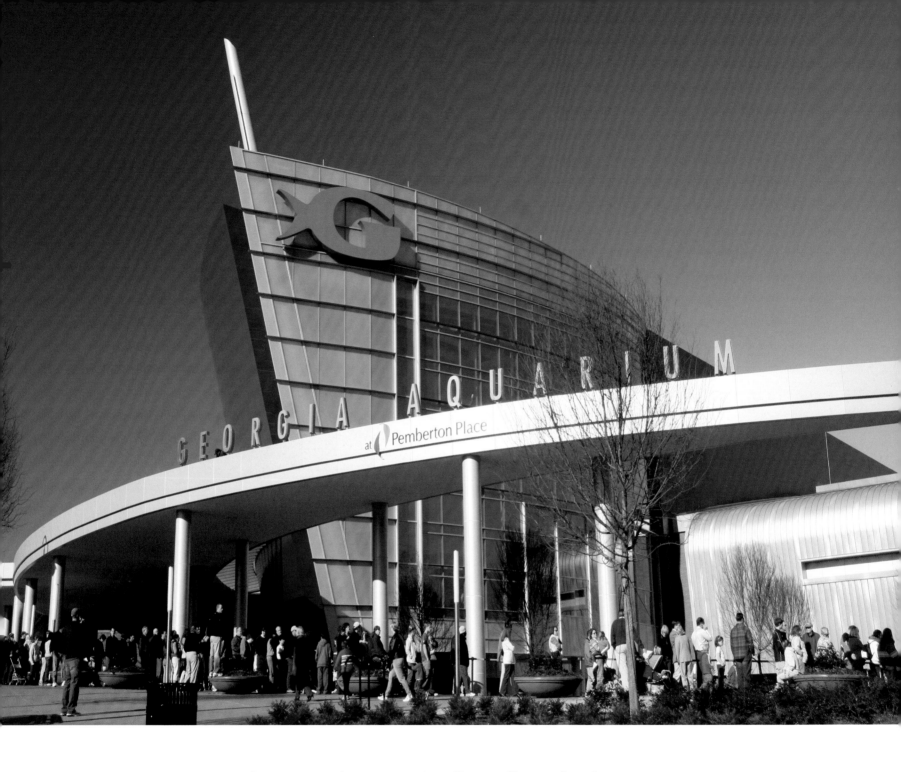

At the Georgia Aquarium, 8 million gallons of tank space showcase marine and freshwater animals in 60 habitats. Displays range from the Amazon River to the icy polar seas, creating a world class education facility and tourist destination.

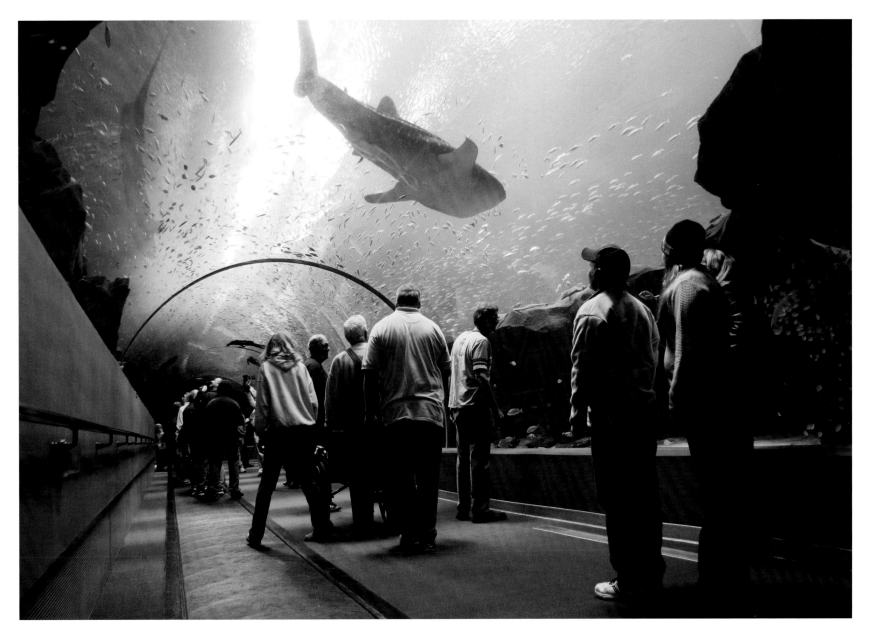

A private donation enabled the Georgia Aquarium to build a 6.2 million gallon tank—big enough to house two whale sharks and nearly 100,000 other fish. Visitors marvel at the giant creatures from a 100-foot tunnel through the tank.

Overleaf–
Along with its famous fountain, Centennial Olympic Park includes acres of green space formal gardens, two outdoor stages, and a picnic area. The pathways are paved in Olympic bricks, each in honor of a person who donated funds to the park.

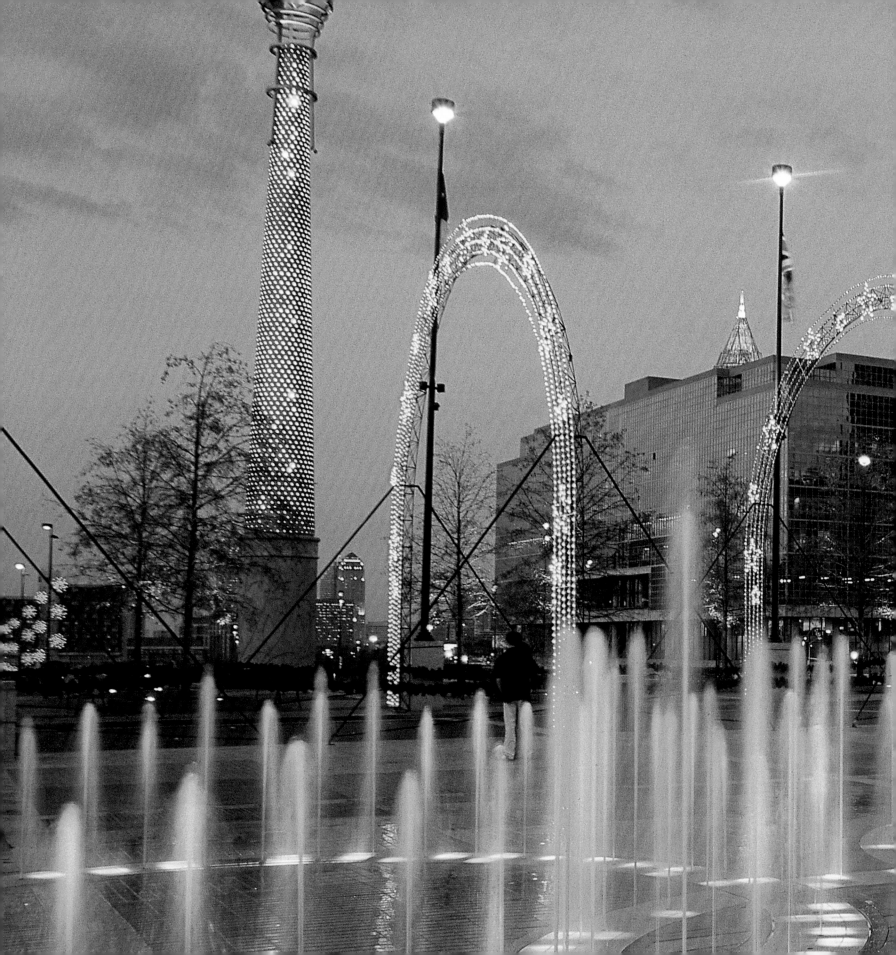

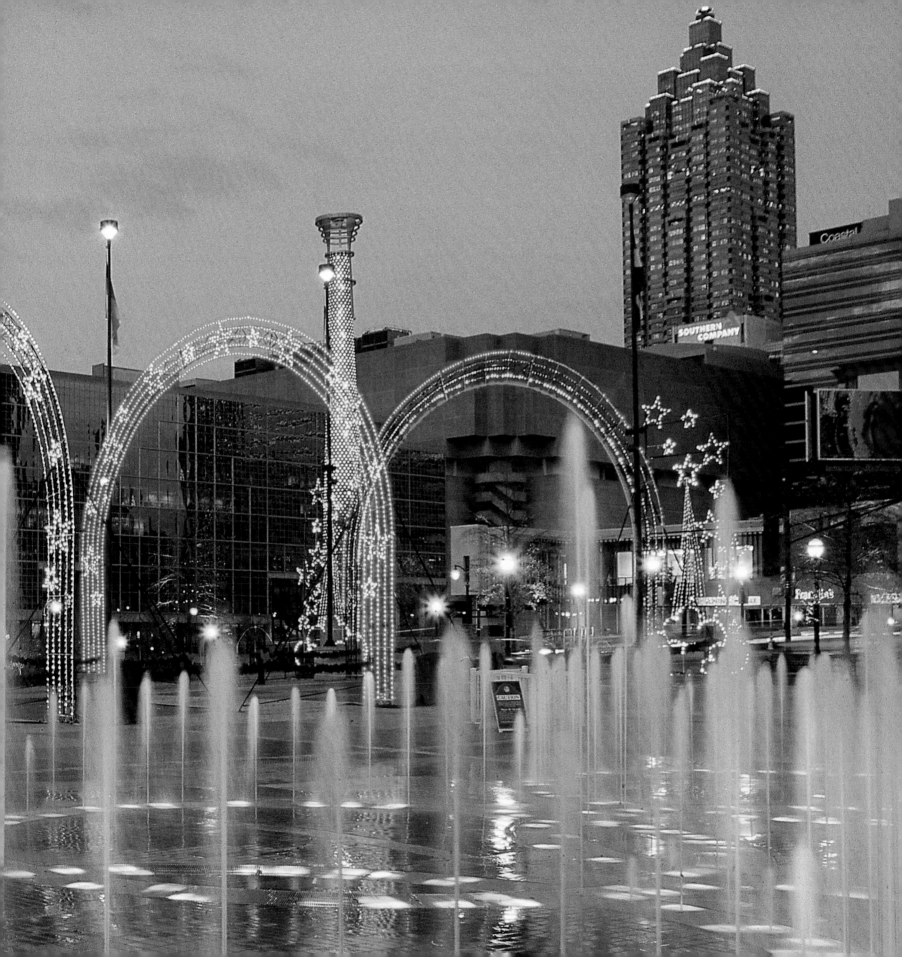

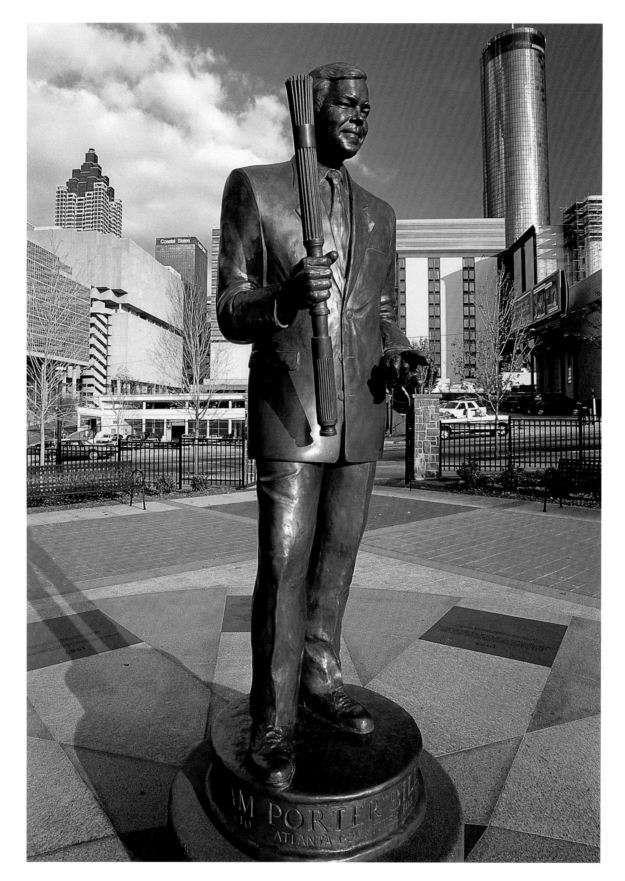

This statue of Billy Payne in Centennial Olympic Park recognizes the man's extraordinary efforts to stage the 1996 Olympics. A former college football player and a prominent real-estate lawyer, Payne was named president of the Olympic organizing committee in 1988, and led Atlanta to become the first city ever to win a bid for the Olympics on its first attempt.

One of Atlanta's tallest buildings, SunTrust Plaza soars to 871 feet high. The edifice, with its distinctive two-tone gray granite exterior and gleaming glass crown, was designed by architect John Portman, Jr., and completed in 1992. The faceted exterior allows up to 36 corner offices on each floor.

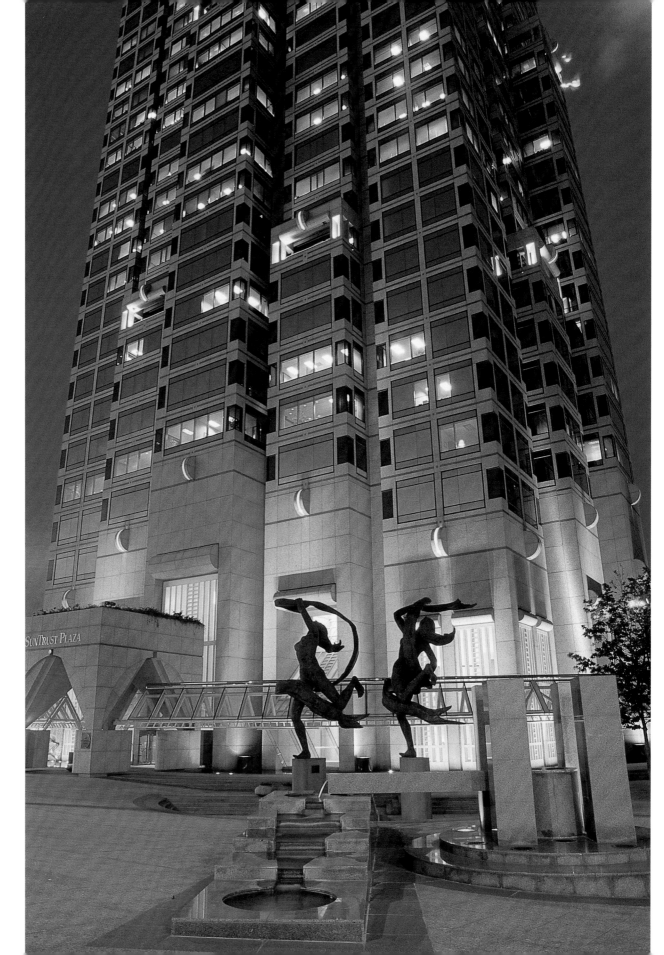

Sculptures grace the landscaped approach to SunTrust Plaza, and the lobby and atrium within. An art gallery in the lower lobby, along with eateries and retail shops, make this a popular visitor as well as a commercial destination.

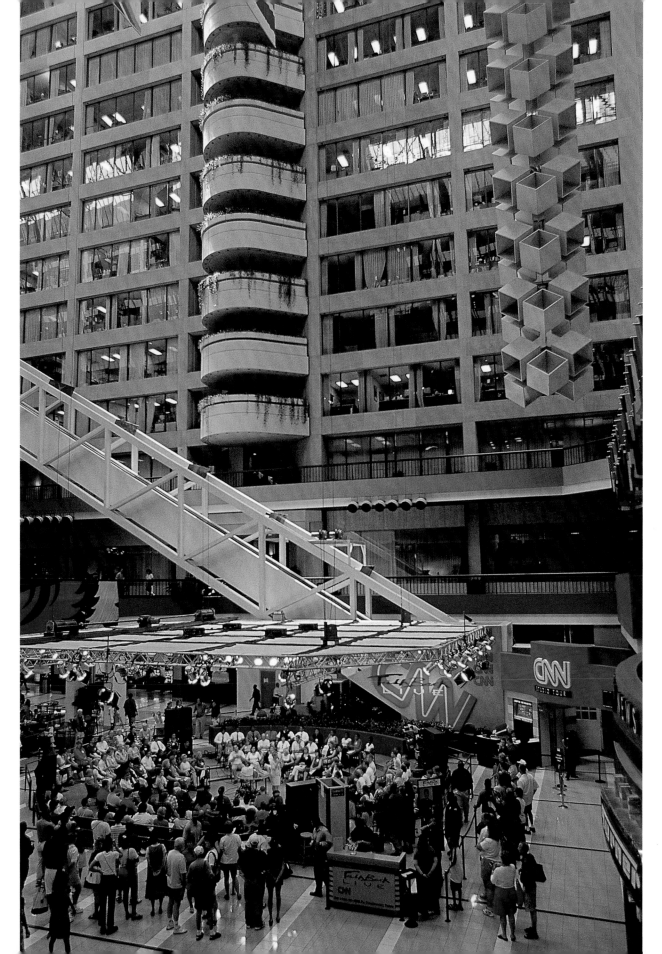

When CNN began broadcasting on June 1, 1980, the news network reached 1.7 million families. Within two decades, the network captured 80 million viewers in the United States and another 200 million internationally.

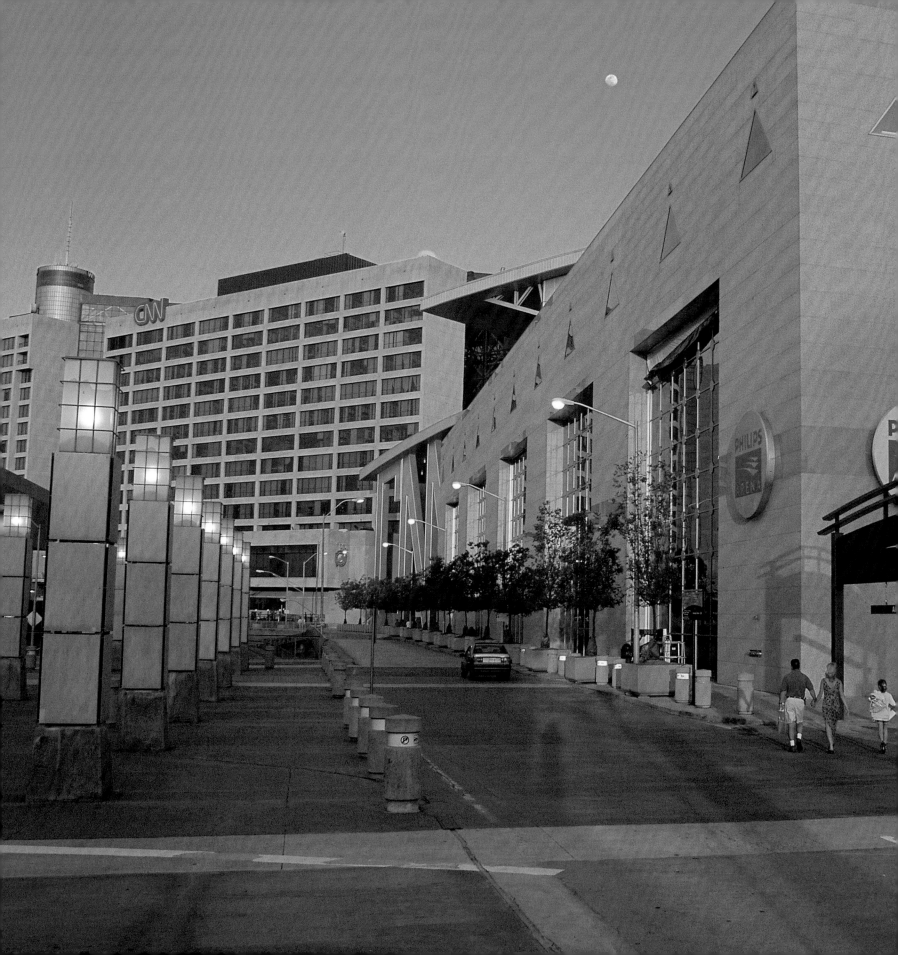

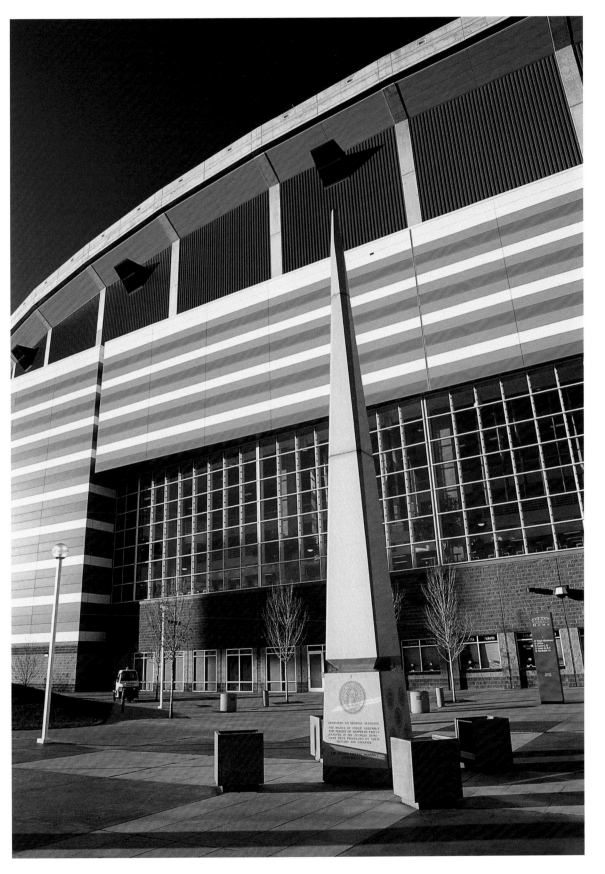

Home of the Atlanta Falcons football team, the 27-story-high Georgia Dome encloses 8.6 acres. It is the largest cable-supported domed stadium in the world and seats more than 70,000 fans.

FACING PAGE—
CNN's studio tours allow visitors to make headline news announcements, explore a behind-the-scenes newsroom, and discover the secrets of the broadcasting trade.

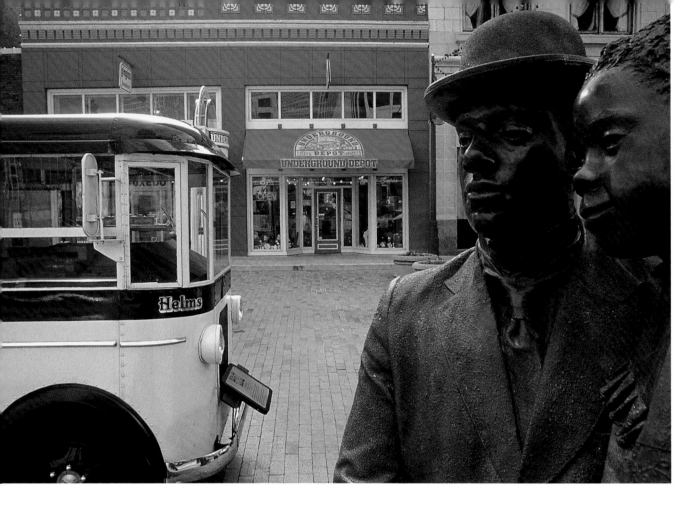

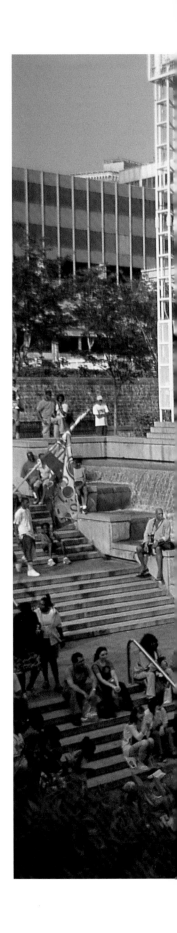

Reconditioned cars and trucks on display at Underground
Atlanta include this 1947 Divco, manufactured in Detroit.
The vehicle was used by Helms Bakeries to deliver breads
and pastries door-to-door in Atlanta until 1969.

In the early 1900s, downtown Atlanta was a web of railway
lines and a hub of industry, leaving little room for pedestrians.
The city built bridges and elevated streets over the tracks,
and eventually the lower level—the "underground"—was
forgotten. That changed in 1969, when Underground
Atlanta—an entertainment and shopping complex—opened.

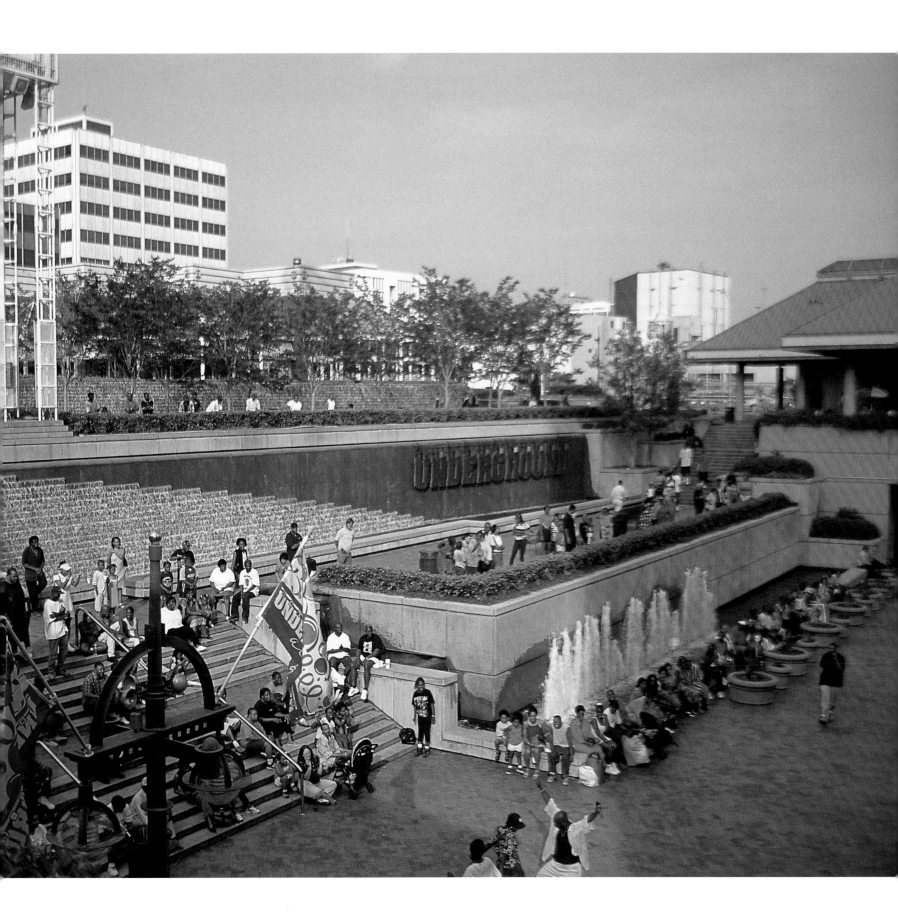

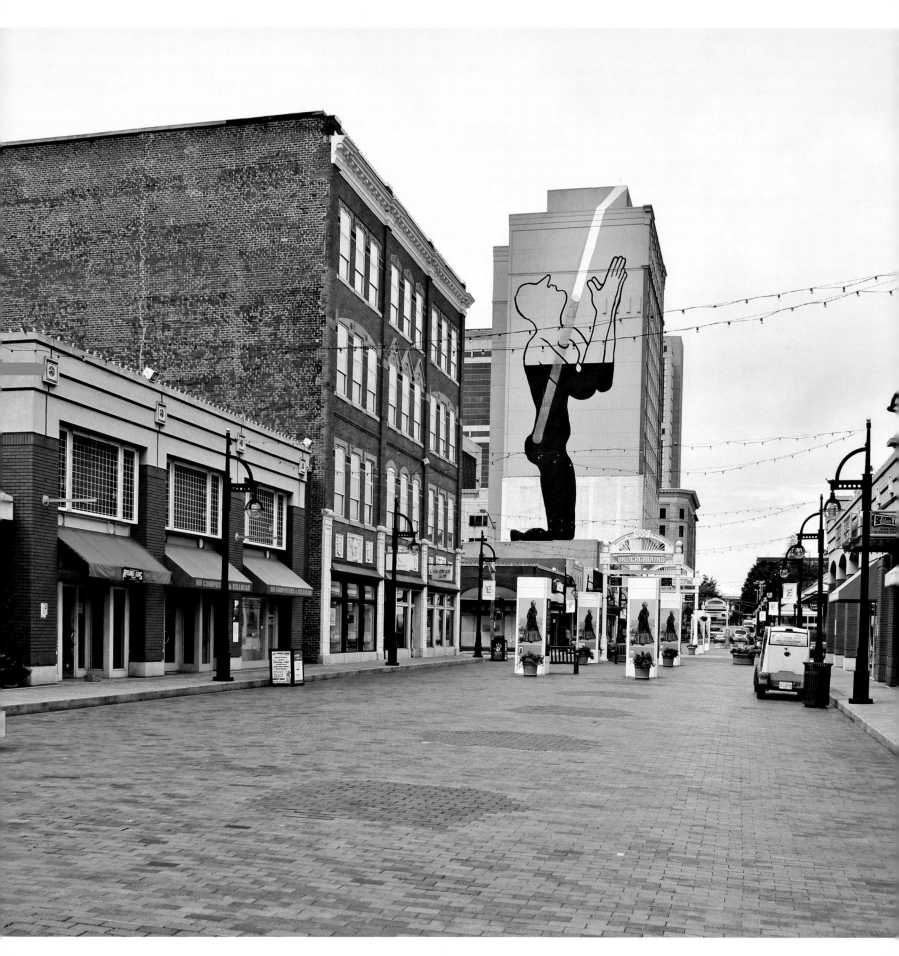

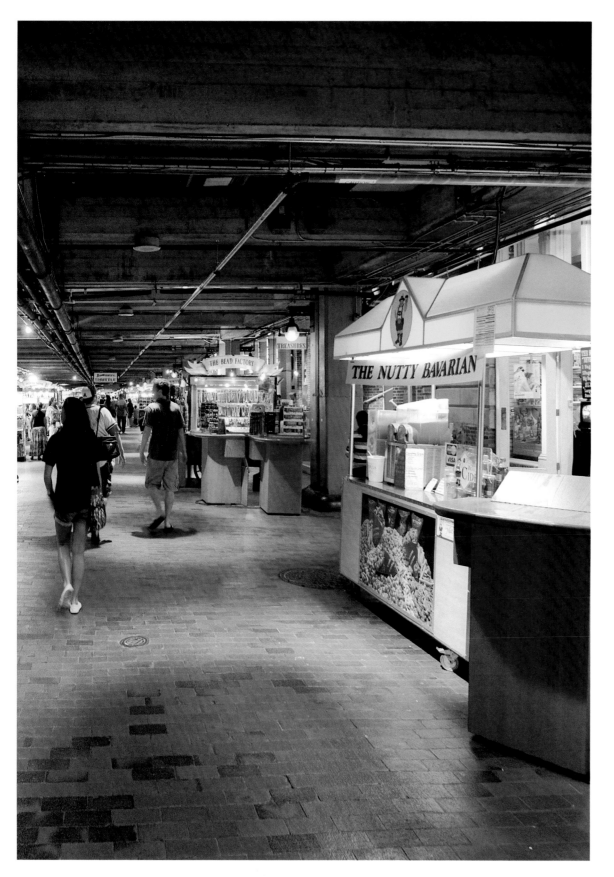

The colorful pushcarts of Humbug Square in Underground Atlanta have replaced hawkers and scam artists who operated in this area a century ago, before the new city arose on its raised viaducts. Today's vendors offer everything from local artwork to aromatherapy oils.

FACING PAGE—Underground Atlanta expanded in the late 1980s, adding new stores, pushcart retailers, and more access points to the streets above. From children's rides to fine dining restaurants, there is much to attract visitors of all ages.

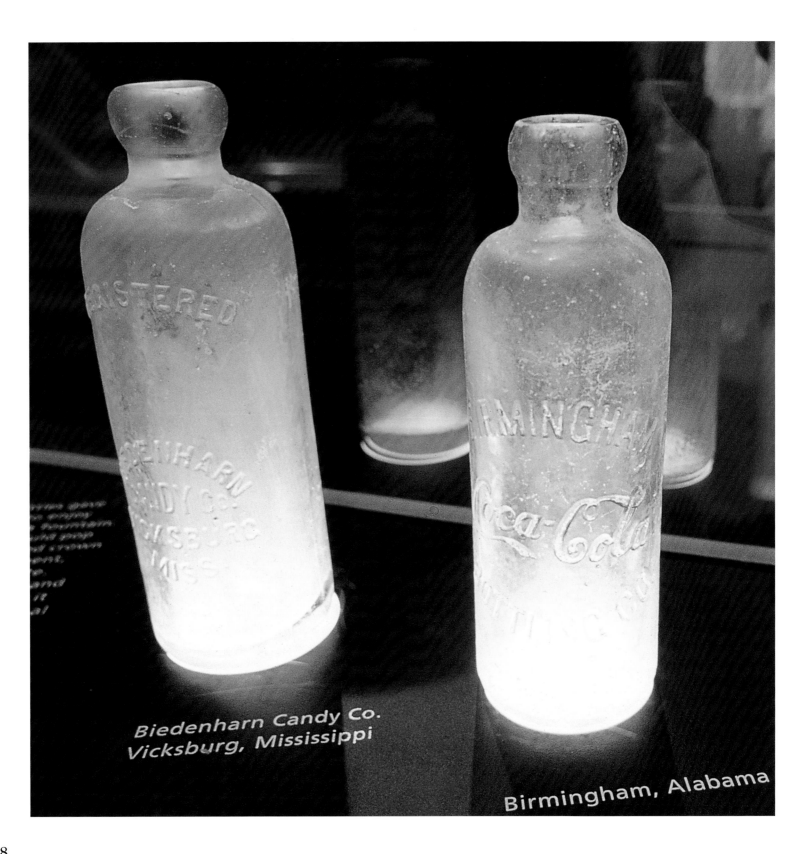

Biedenharn Candy Co.
Vicksburg, Mississippi

Birmingham, Alabama

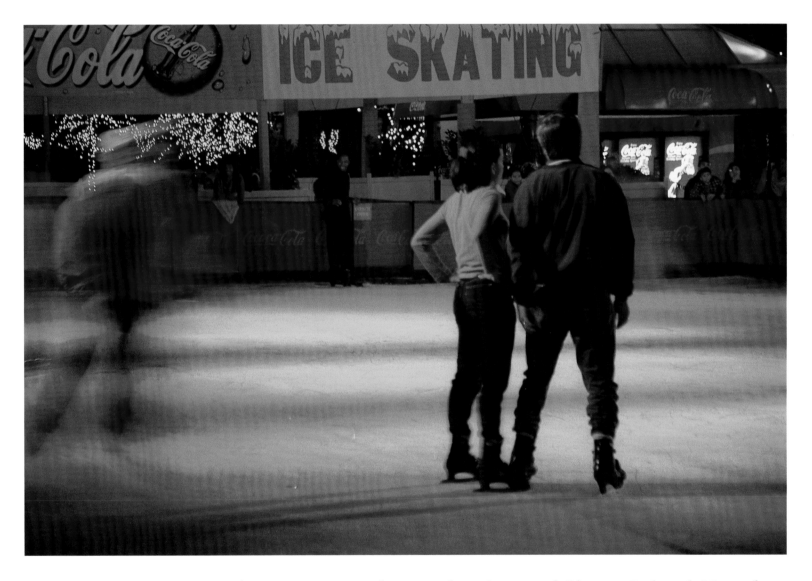

Atlanta opens its ice-skating rink in Centennial Olympic Park each November. The streets and walkways surrounding the rink are bedecked in hundreds of thousands of lights for the season, lending a festive air to downtown.

The World of Coca-Cola, a three-story pavilion in downtown Atlanta, celebrates the soft drink's century-long journey from a single pharmacy soda counter to store shelves in 200 nations. More than a billion Cokes are served around the world each day.

Steve Polk Plaza, with its wide pedestrian spaces and its central fountain, is named for the former state trooper who helped direct the Georgia Building Authority in the mid to late 1900s. This has also been known as Coke Plaza since the World of Coca-Cola opened its doors in 1990.

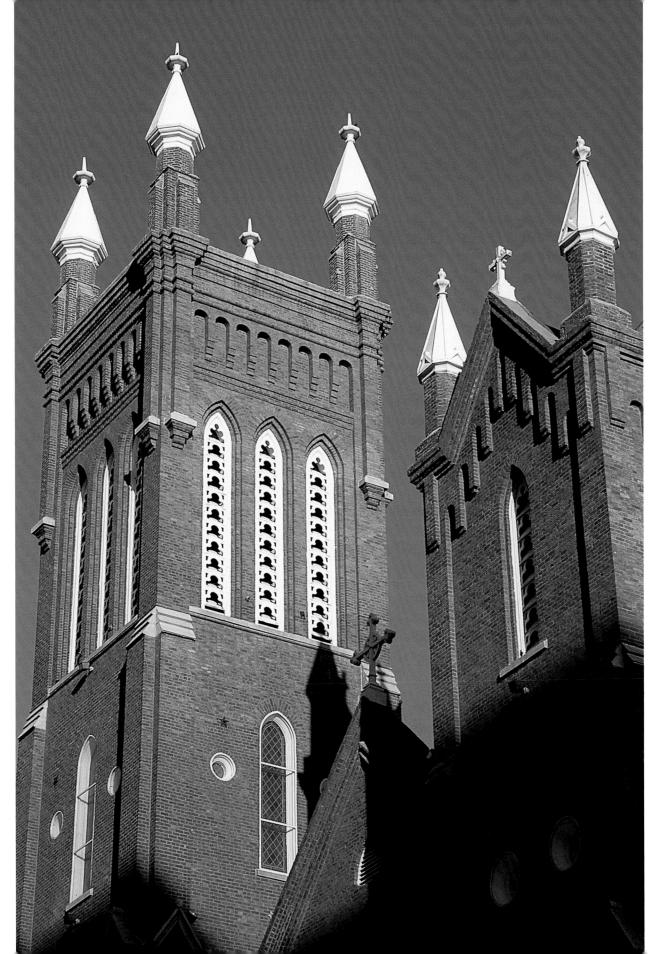

Bishop Augustine Verot of Savannah traveled to Atlanta in 1869 to lay the cornerstone of the Shrine of the Immaculate Conception. Despite decades of prosperity, the parish declined after World War II. Church leaders considered selling the property to the state, until rector James J. Grady and Father Donald Kiernan raised $117,000 for its preservation and restoration.

41

When Georgia authorized renovations to the State Capitol in 1956, citizens of Lumpkin County donated 43 ounces of gold, in memory of the area's nineteenth-century gold rush. The gold was delivered to the capitol by wagon train and now adorns the dome.

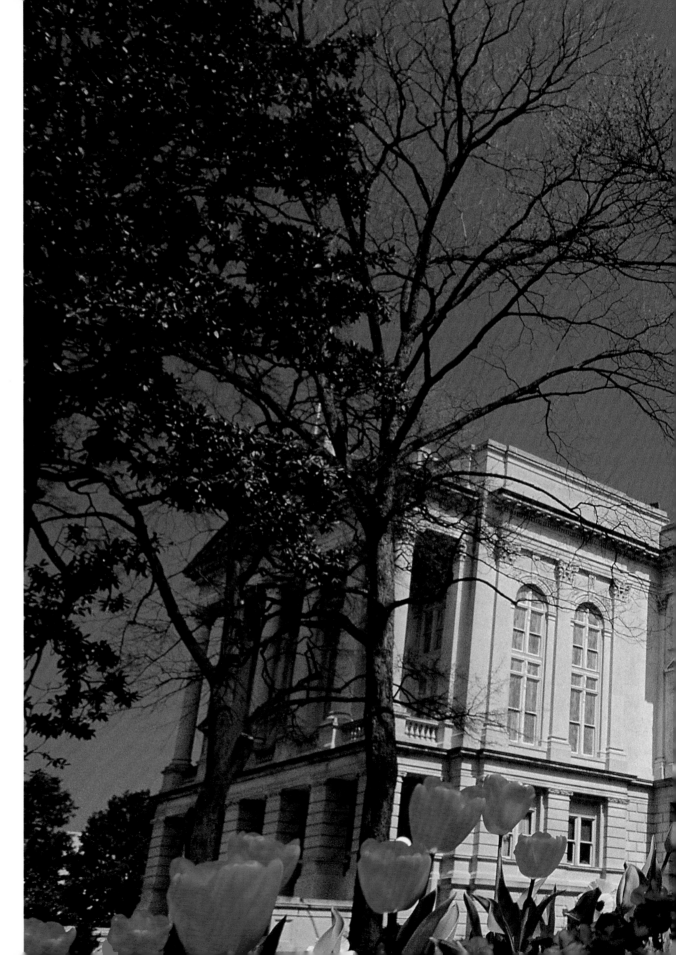

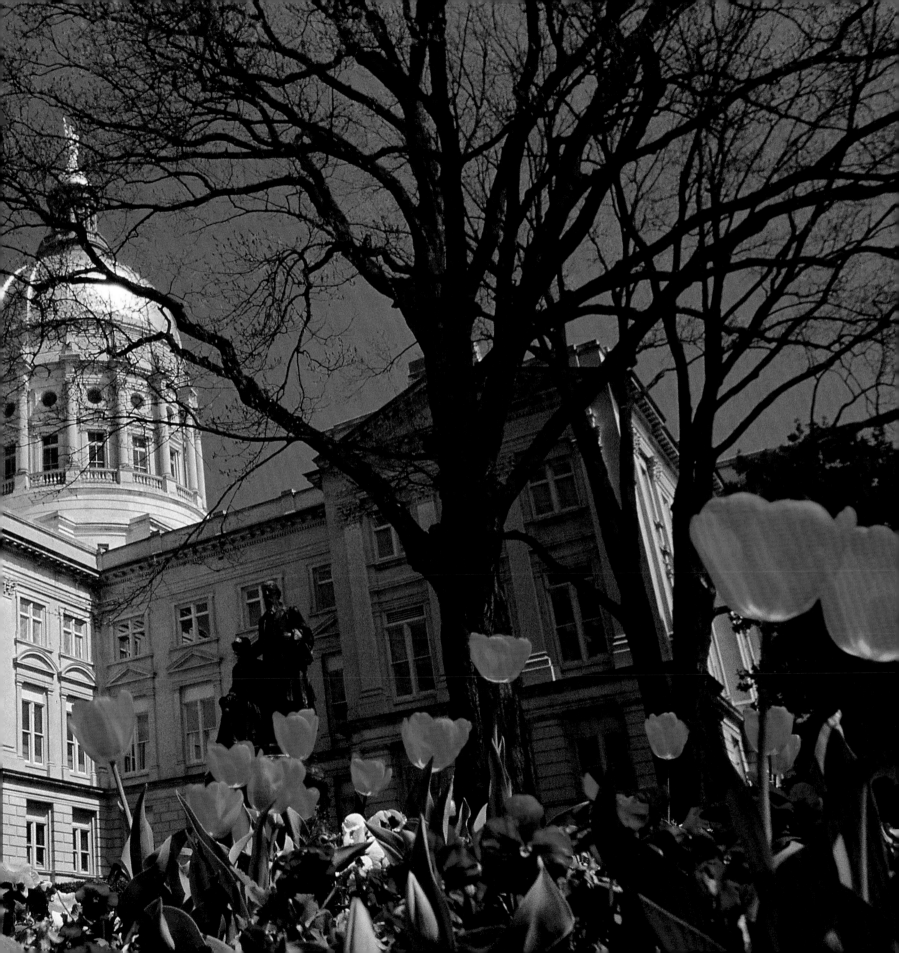

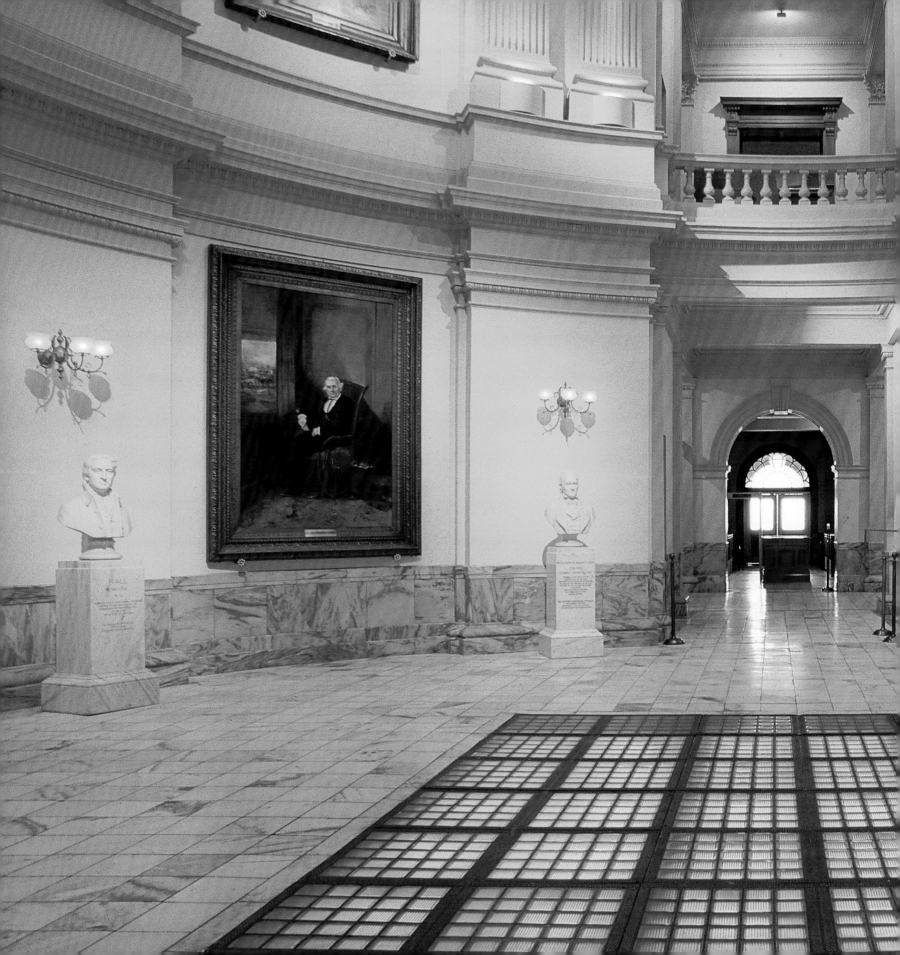

Georgia's State Capitol was an architectural wonder when it was built in the 1880s. It was one of the first public buildings in America to boast elevators and central heating. The walls and floors are built with about 1.5 acres of Georgia marble, and the central rotunda is more than 272 feet high.

45

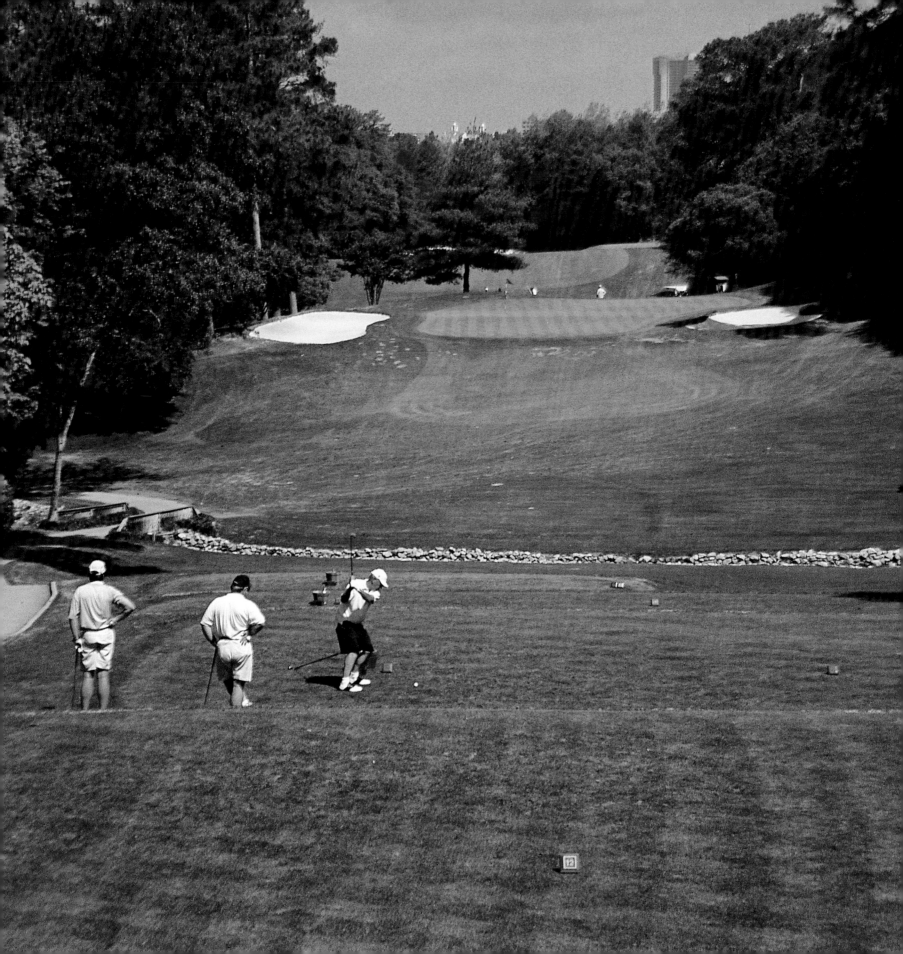

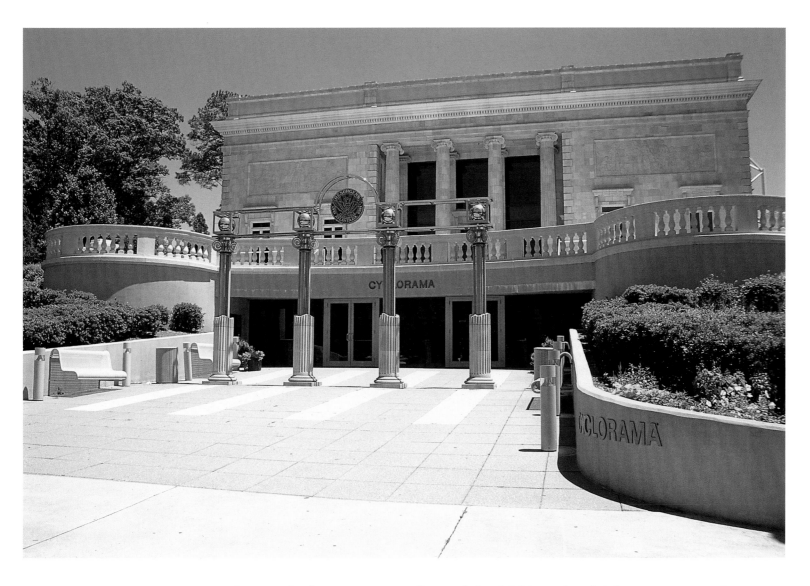

Atlanta's Cyclorama is a retelling of the 1864 Battle of Atlanta. Large-scale murals designed to be displayed in cylindrical rooms, cycloramas were popular throughout Europe in the late 1800s. The Cyclorama is now on display in Grant Park.

Atlanta's golf courses are gaining popularity among both residents and touring professionals. Whether it's a PGA Championship at the Atlanta Athletic Club or a friendly after-work round at Hampton Golf Village, a variety of courses cater to enthusiasts of all levels.

From downtown's industrial-style lofts to the exclusive townhouses of Buckhead, the heritage Georgian homes of Brookhaven, and the sprawling gardens of Ansley Park, each Atlanta neighborhood has its own unique character. Just east of downtown, Inman Park was the city's first suburb, now listed on the National Register of Historic Places.

A spring festival brings visitors to the shady gardens and restored homes of Inman Park. When the first homes were built here in the 1890s, the new suburb was connected to downtown by a trolley line. Residents included Asa Candler, founder of Coca-Cola.

51

Atlanta native Martin Luther King, Jr. was born in 1929. Known for his elegant oratory and passionate beliefs, King was a leader in the American civil rights movement and won the Nobel Peace Prize in 1964. He was assassinated on April 4, 1968. Martin Luther King, Jr. National Historic Site was established 12 years later to honor his achievements.

FACING PAGE—
Set in Peace Plaza at Martin Luther King, Jr. National Historic Site, the *Behold* monument by sculptor Patrick Morelli celebrates the life of Martin Luther King, Jr. Morelli chose a pose inspired by an ancient African tradition of holding newborns toward the sun, that they might behold a power greater than themselves.

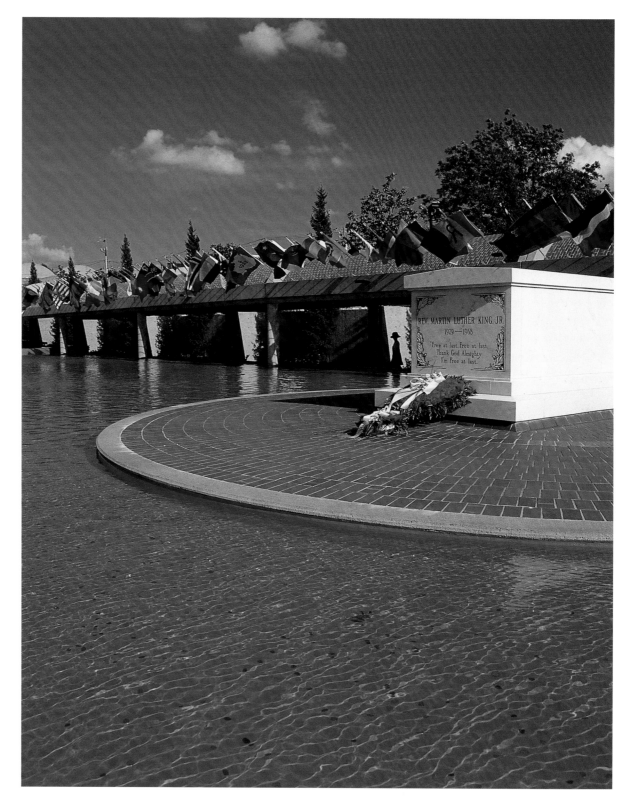

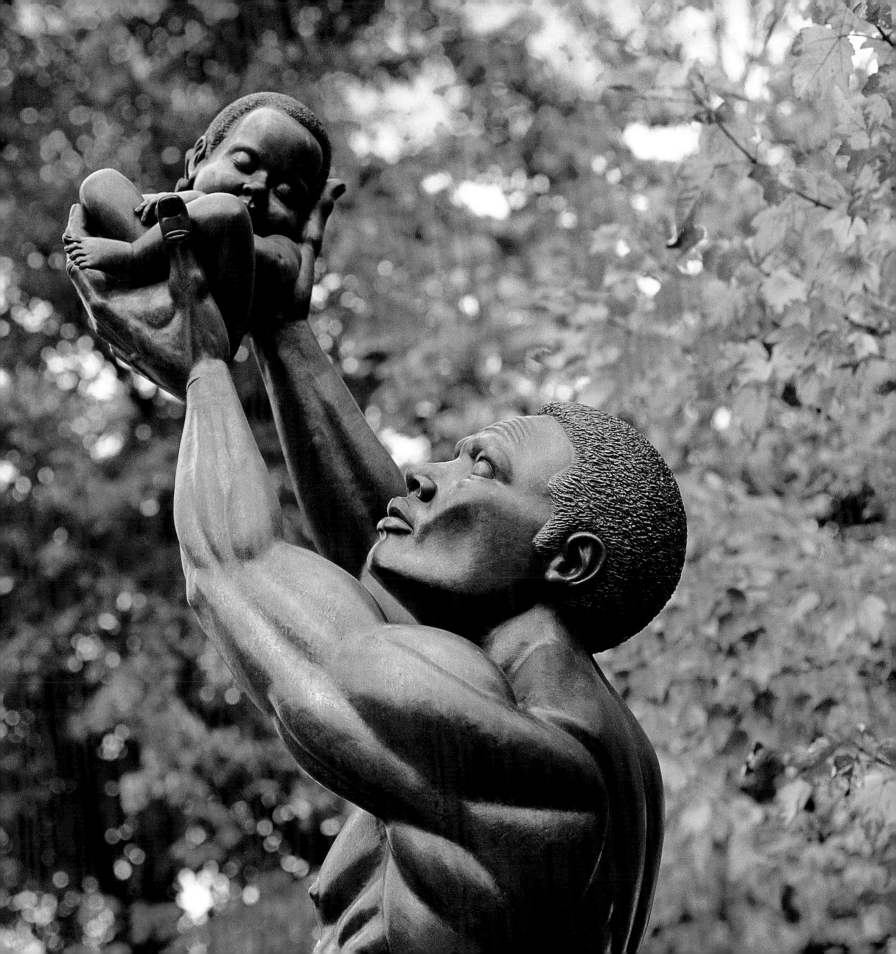

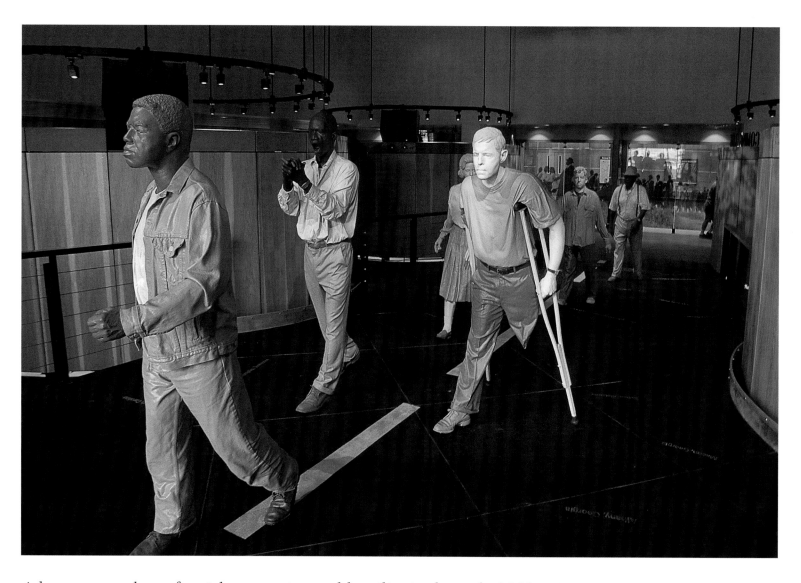

Atlanta was a place of racial segregation and hostility in the early 1900s. For a time, the city was the center of Klu Klux Klan activities in the South. From 1960, when he returned to the city as a pastor, until his assassination in 1968, Martin Luther King, Jr. led a massive civil rights movement to end inequality. In 1973, Atlanta elected a black mayor for the first time.

The Varsity Drive-In, the largest restaurant of its kind in the world, has been serving chili-dogs, fries, and onion rings to its customers since 1928. Soon after the restaurant opened, owner Frank Gordy hired someone to run to the curb and take customers' orders. Before long, he had purchased the parking lot next door and was employing 100 carhops.

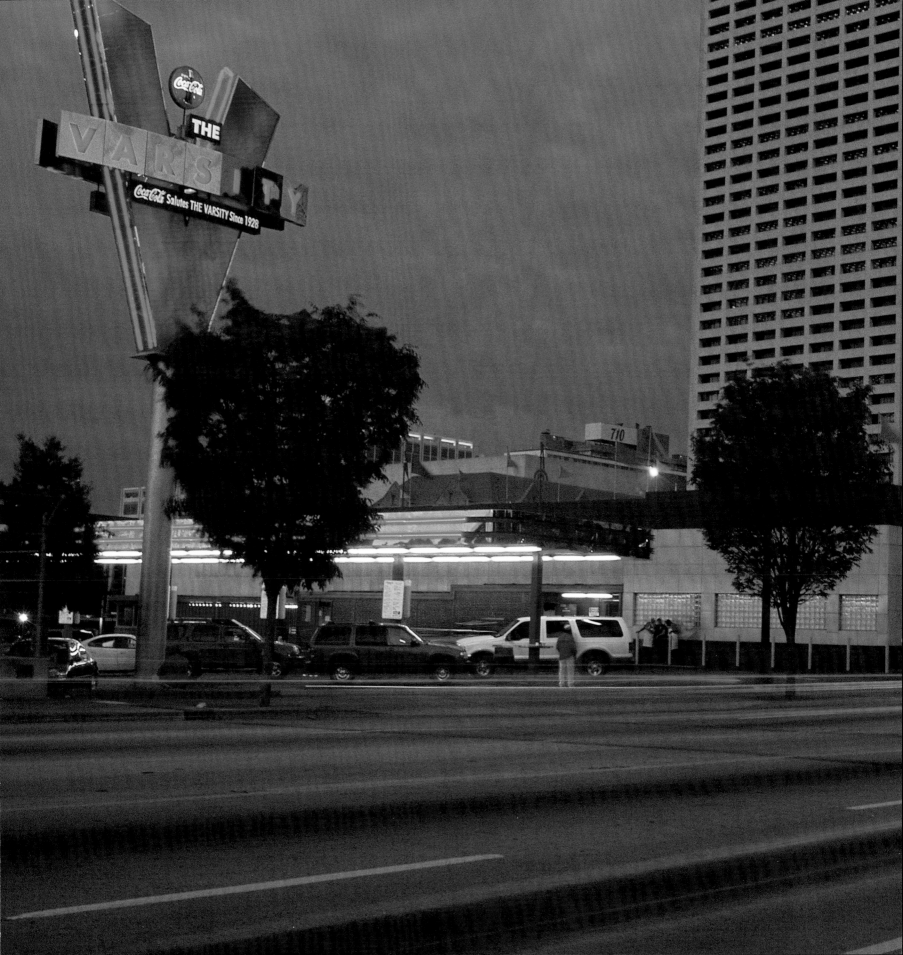

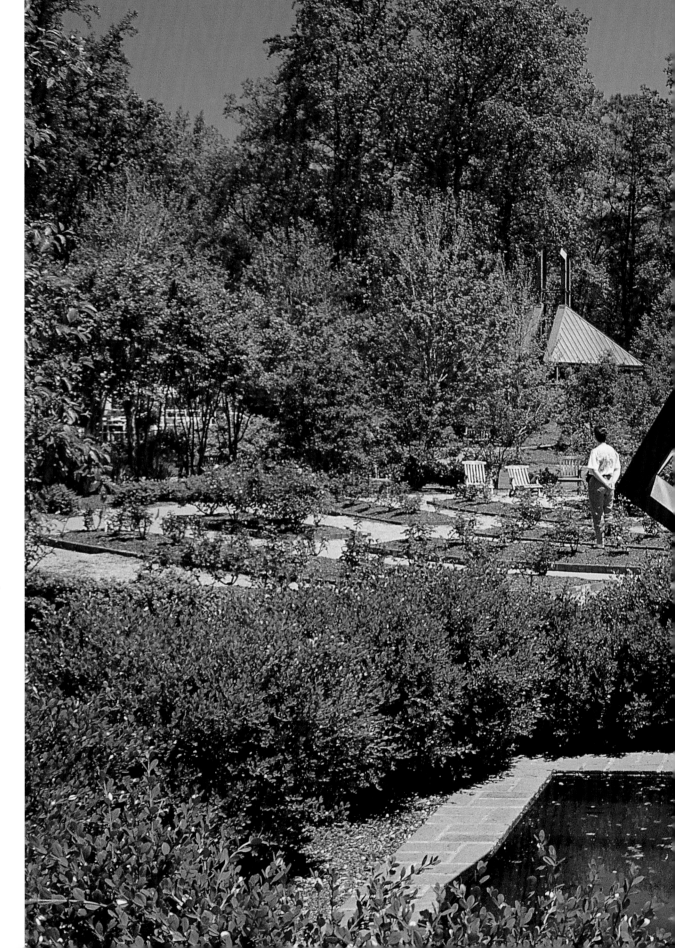

Wandering the paths of the Atlanta Botanical Garden, sightseers could find themselves in a formal Japanese garden, a vine arbor, or a mountain bog. Medicinal and culinary herbs surround a knot garden, while perennial borders lead to the edge of Storza Woods, a mature hardwood forest.

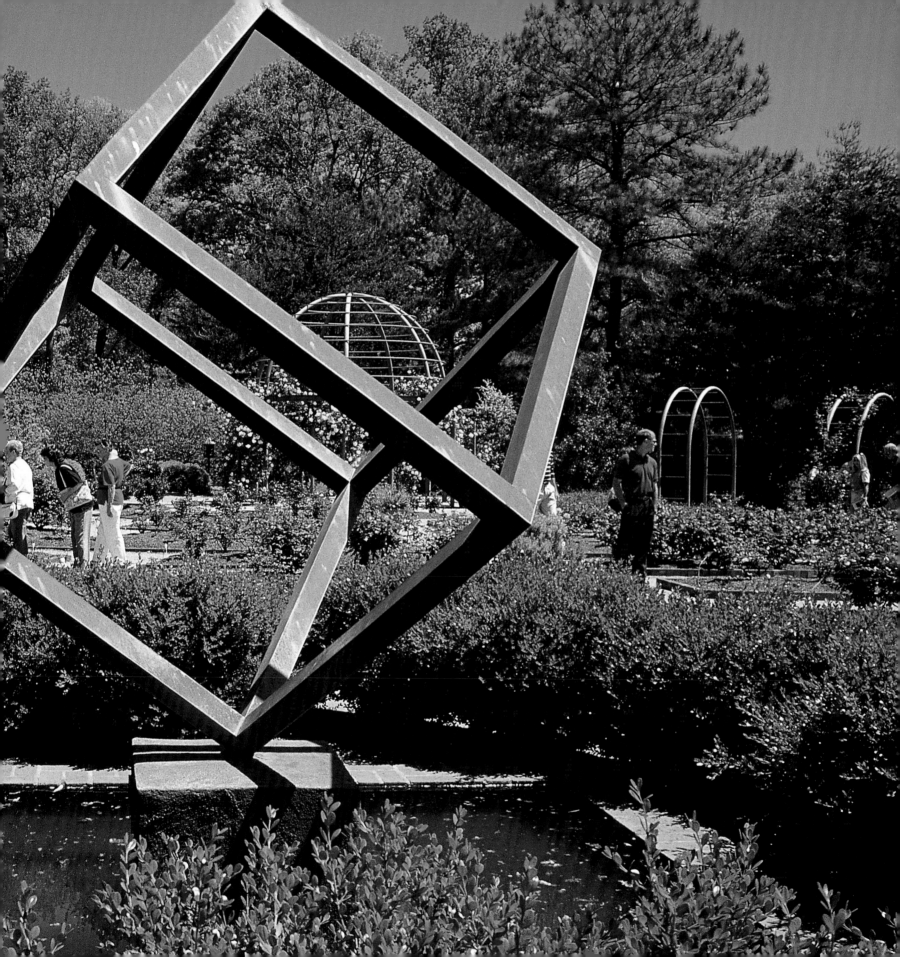

The work of the Atlanta Botanical Garden extends far beyond the 15-acre outdoor greenery. The garden works in partnership with landowners, government, and conservation groups to help protect native plant species throughout the southern states. The garden also nurtures rare and endangered species of plants and even animals from around the world, such as the blue poison frog of South America.

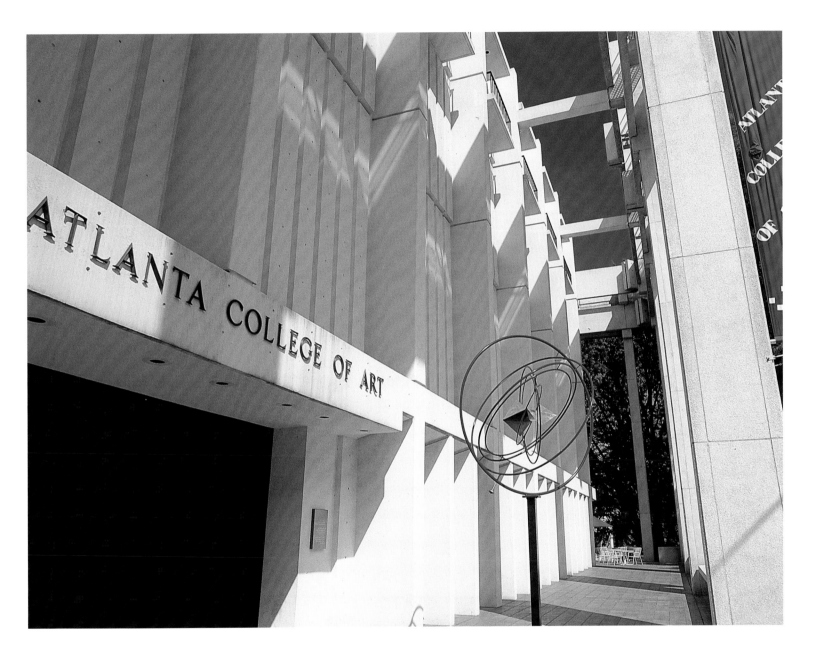

Sculpture, painting, print making, and electronic arts studios allow students at the Atlanta College of Art to explore a diverse range of skills through a four-year degree program. Founded in 1928, the college boasts a student to faculty ratio of twelve to one, guaranteeing individual attention and mentoring for future artists.

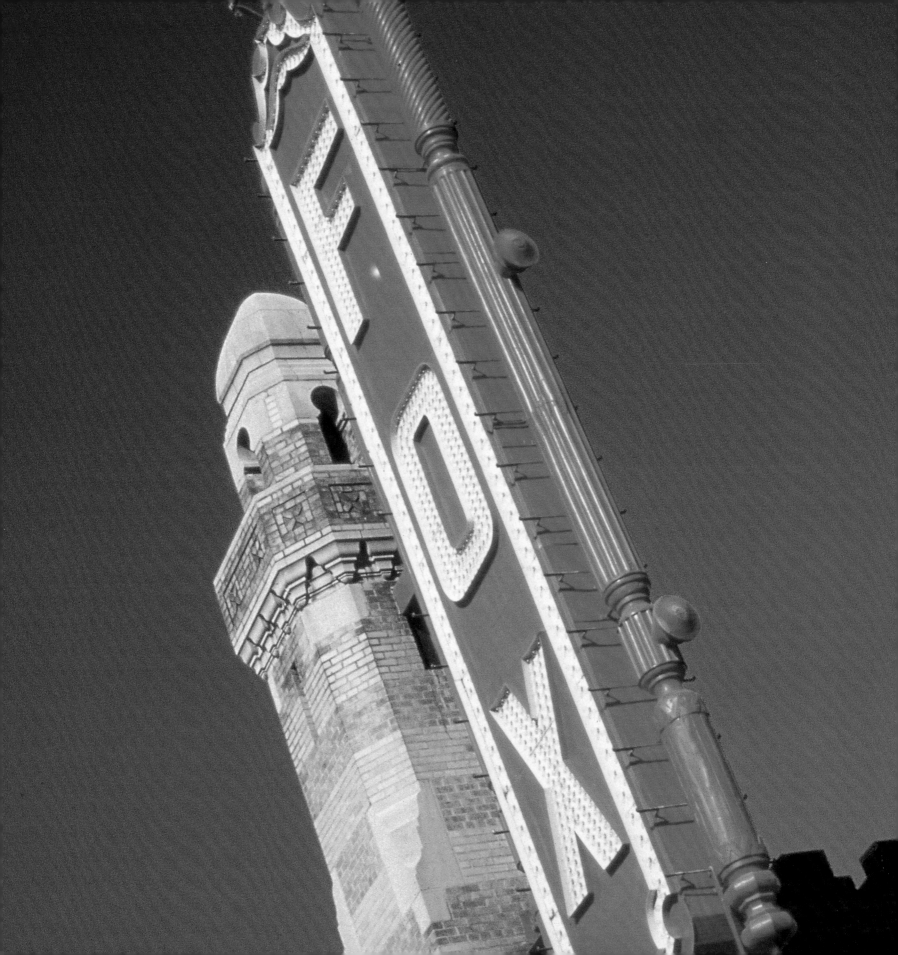

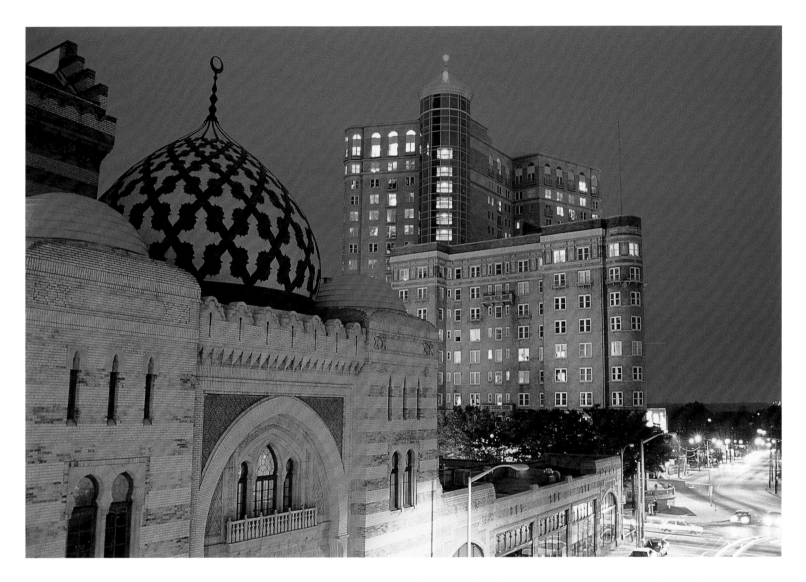

Now Fox Theatre, the Yaarab Temple Shrine Mosque was built in the 1920s by the Shriners. Its extravagant architecture and finishings included Middle Eastern-style onion domes, a re-creation of an Arabian courtyard, complete with the illusion of a changing sky, and opulent canopies, balconies, and stage furnishings.

As the Depression loomed and upkeep of the mosque became difficult, the Shriners arranged for movie giant William Fox to show talking pictures and live stage shows in the facility. Success was short-lived, and the theater faced bank-ruptcy, until a non-profit organization, Atlanta Landmarks, bought it in the 1970s. Thanks to massive fundraising the restored building is again in operation.

Founded more than 30 years ago, thanks to a $4-million donation by Coca-Cola tycoon Robert W. Woodruff, the Woodruff Arts Center combines performance spaces and visual art displays in one facility. The idea for the complex arose in the 1960s, in memory of 122 leaders and supporters of the Atlanta arts community who were killed in a plane crash outside Paris.

The High Museum of Art houses more than 10,000 works in a variety of mediums by artists from around the world. Founded in 1905, the museum is named for early benefactor Mrs. Joseph M. High. It is best known for its exhibits of nineteenth- and twentieth-century American works, as well as its growing collection of American folk art.

FACING PAGE—
The High Museum of Art is itself a work of art. It was designed by Richard Meier, a New York architect known for his use of enamel panels, glass, and strong linear elements. The museum opened in 1983, and was named one of the 10 best designs of the 1980s by the American Institute of Architects.

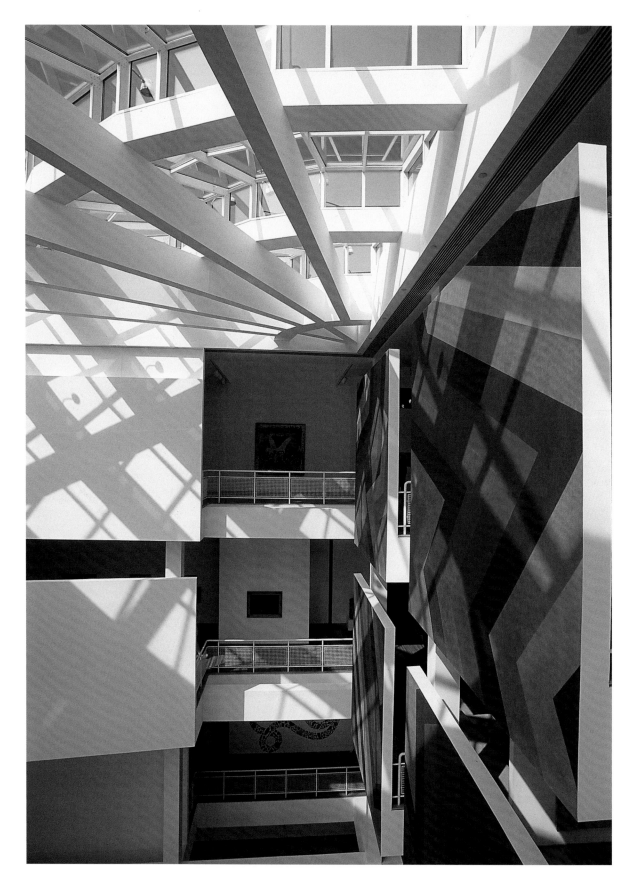

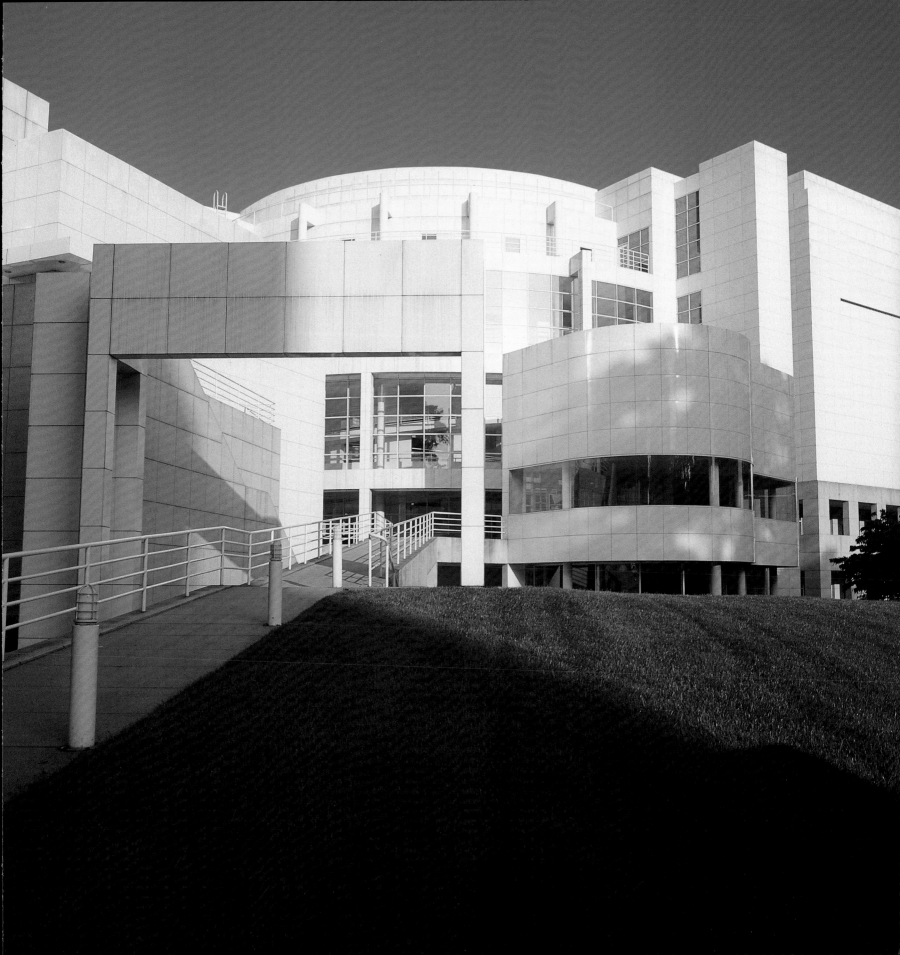

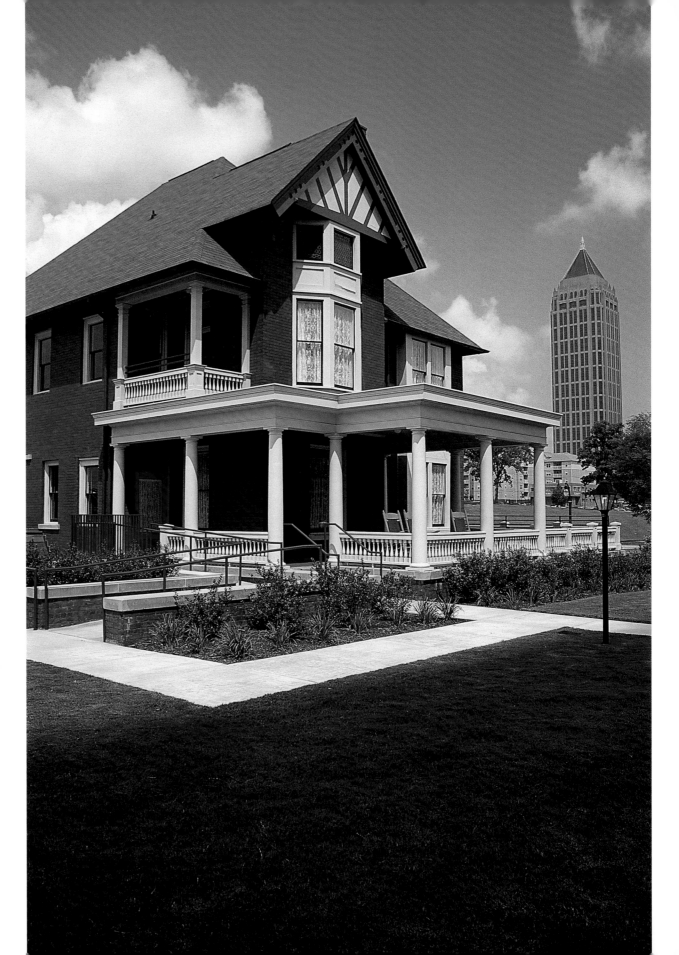

Margaret Mitchell rented a suite in this small Atlanta apartment building between 1925 and 1932, dedicating herself to the creation of *Gone With the Wind.* The two-story building is now a museum displaying movie set memorabilia and artifacts from Mitchell's life.

This was once the farm of early local homesteader Benjamin Walker. In 1887, Atlanta citizens purchased 189 acres from Walker to develop a harness-racing track. Later, this was the site of the Cotton States International Exposition. Finally, the city bought the area in 1904 and created Piedmont Park.

OVERLEAF—
With its lush green spaces, Piedmont Park attracts almost 3 million visitors each year. In the early 1900s, Frederick Olmsted, Jr. and his brother John Charles helped redesign the park. The pair were trained by their father, landscape architect Frederick Law Olmsted, designer of New York City's Central Park.

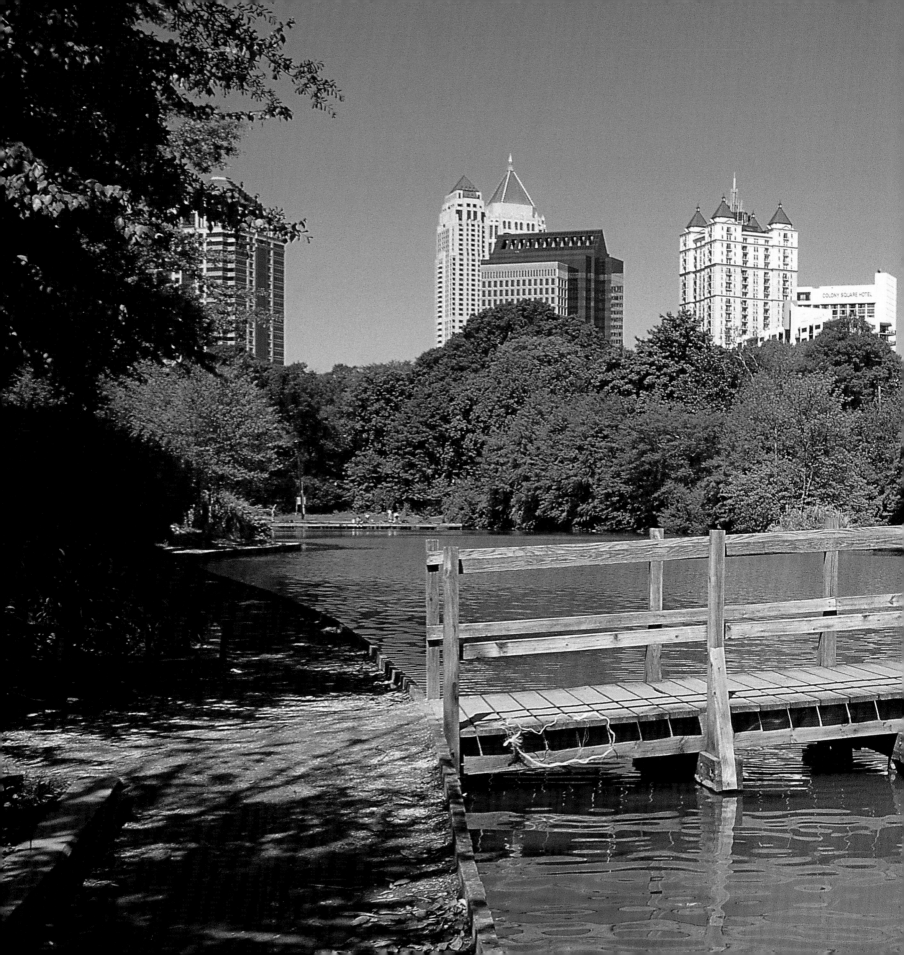

At the Atlanta History Museum, visitors wander through 30,000 square feet of exhibition space to explore the stages of the city's history, stories of the American Civil War, and the lives of some of Atlanta's most prominent citizens.

Protected as part of the Atlanta History Center, Swan House was built in 1928 for cotton fortune heirs Edward and Emily Inman. Named for the decorative swans found throughout the interior, the mansion gives sightseers a view of life in the upper classes during the 1920s and 1930s.

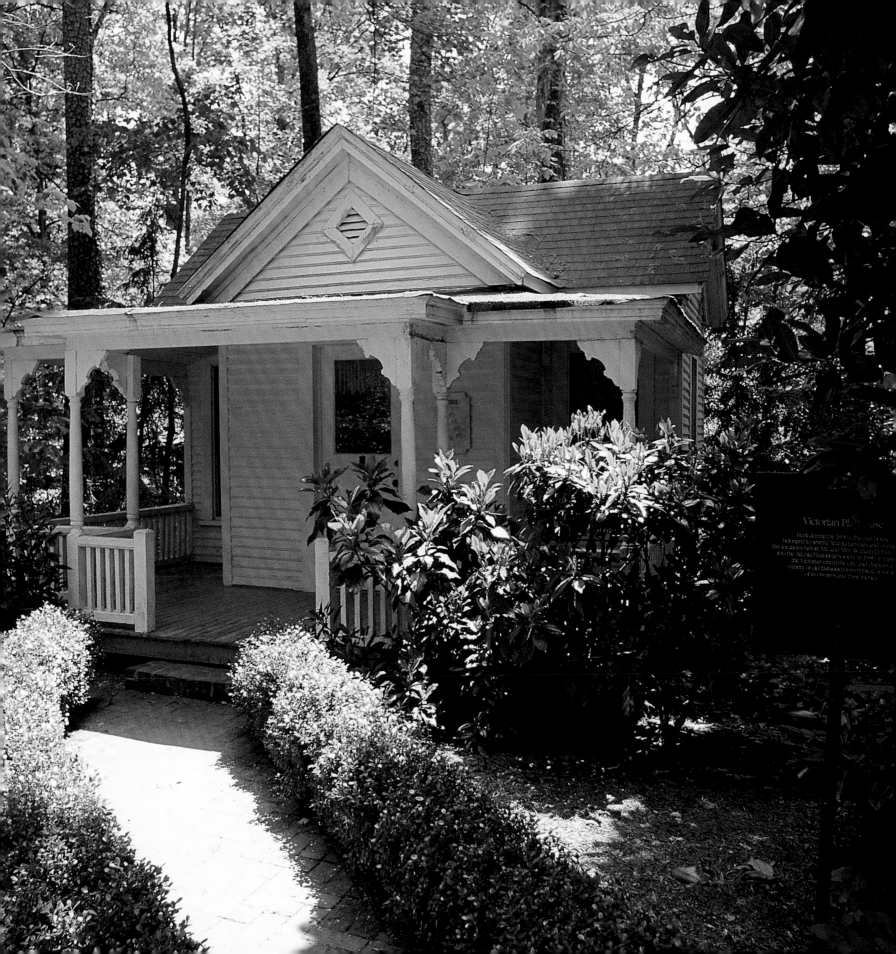

Victorian Playhouse

Built during the 1890s, this playhouse
belonged to several Atlanta families and occupied
five locations before Mr. and Mrs. William H. Kiser
gave it to the Atlanta Historical Society in 1966. It represents
the Victorian era in the city and its graceful
variety of old-fashioned toys, typical of those
of its owners and their friends.

Buckhead, north of Atlanta, combines the best of the corporate, commercial, and residential worlds. Office towers soar over shady streets lined with galleries, specialty stores, tattoo parlors, and vintage clothing shops. Nearby, heritage homes rub shoulders with warehouses transformed into trendy lofts.

Buckhead's Piedmont Road is a lively center of shops and restaurants, popular with both travelers and locals.
One of the first routes to connect downtown Atlanta to the growing suburbs of the early 1900s, this was originally called Plaster Bridge Road in honor of one of the area's first settlers, Benjamin Plaster.

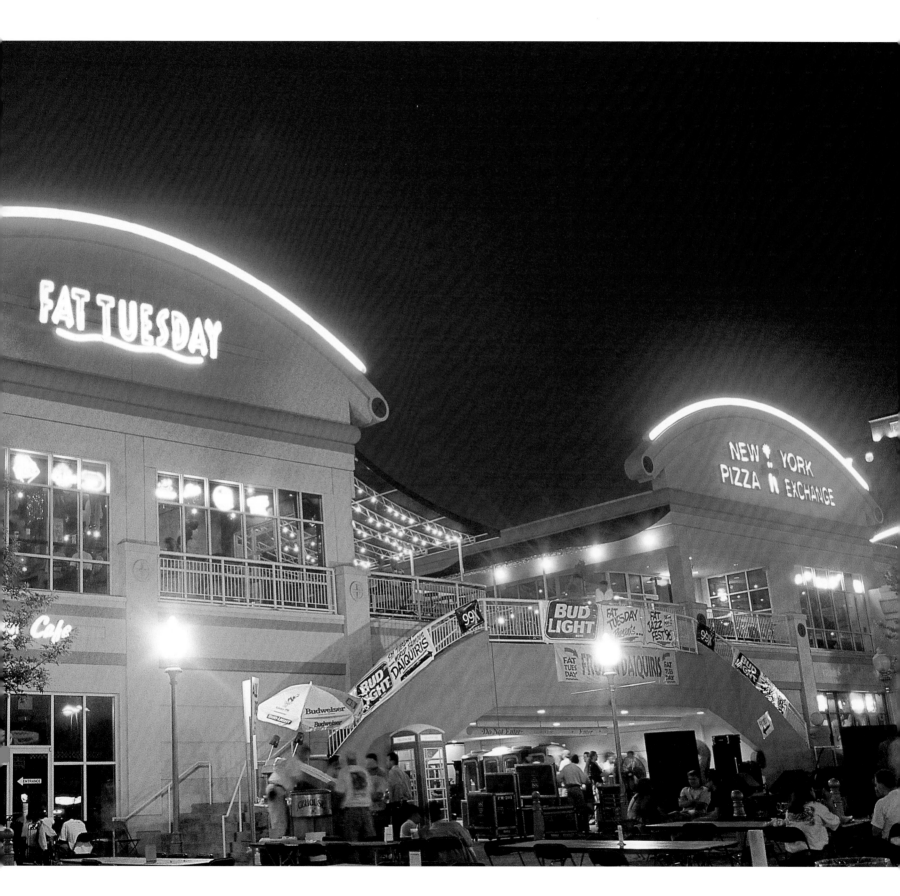

From casual pub-style eateries to fine dining establishments, Buckhead is known for its eclectic mix of restaurants and nightspots. While many of the venues line busy commercial streets, some of the best are tucked away in refurbished heritage homes and cozy cottages.

Emory University's 631-acre Atlanta campus serves more than 12,000 students, many specializing in medicine, business, law, or theology. Among the school's alumni are five Pulitzer Prize winners, six U.S. senators, and 32 United Methodist Church bishops. Emory was founded by the Methodist Church in 1836.

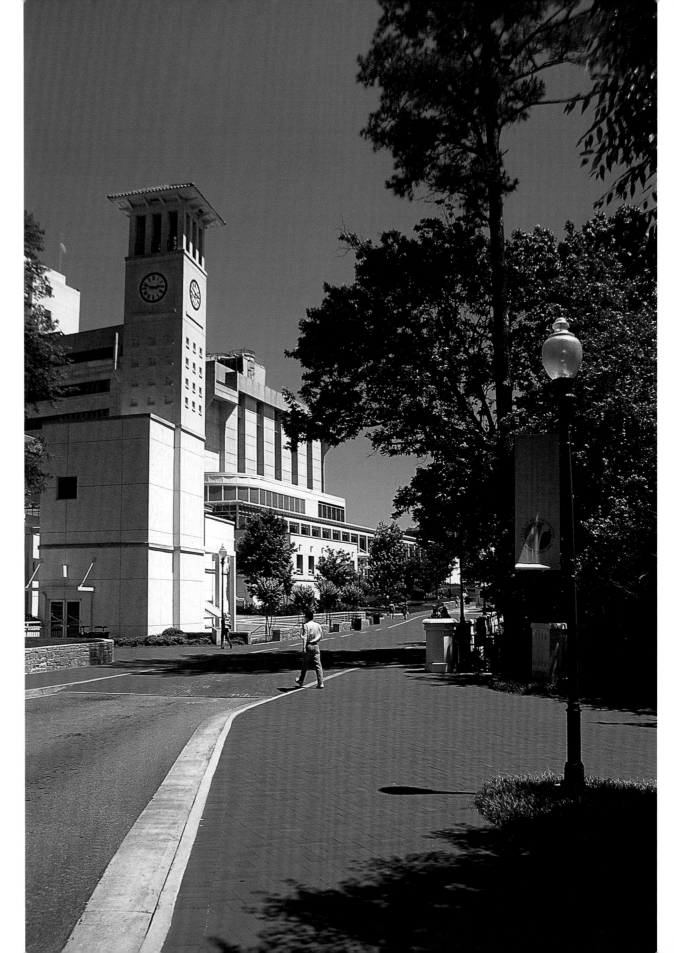

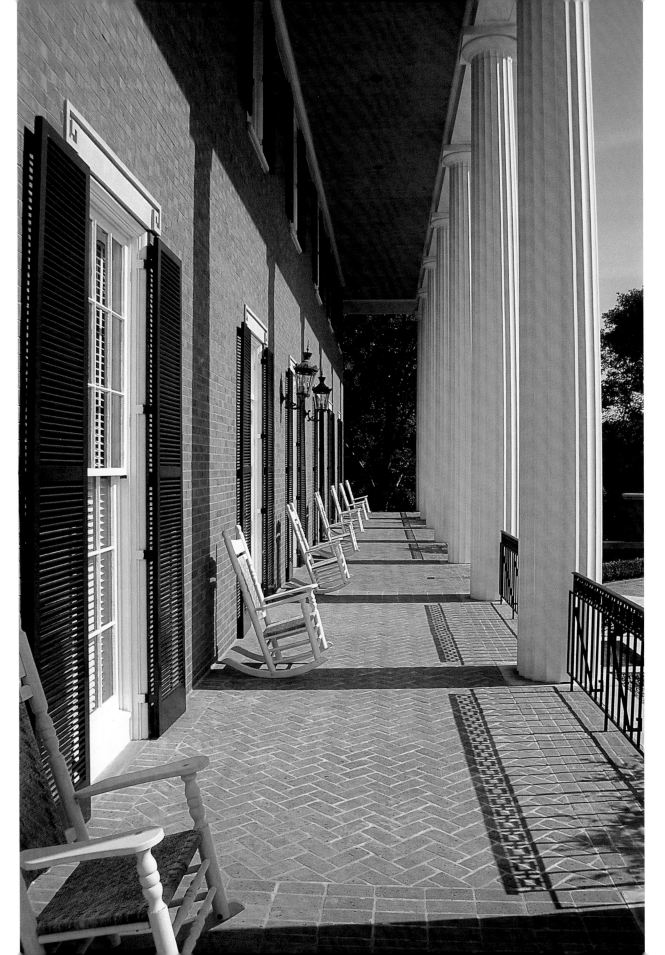

On a tree-lined street in Buckhead, the Governor's Mansion is open for public tours several times a week. Georgia architect A. Thomas Bradbury designed the 30-room Greek Revival home, nestling it within 18 wooded acres. The mansion was completed in 1968.

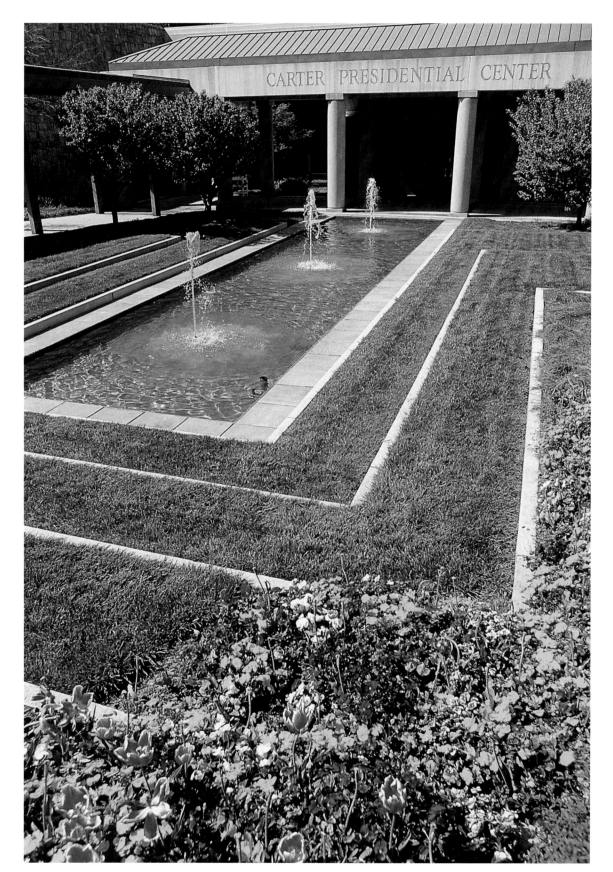

Opened in 1986, the Jimmy Carter Library employs a staff of researchers who search for, analyze, and archive material relating to Jimmy and Rosalynn Carter and their time at the White House. President Carter's private offices and facilities for the charity foundations he supports are part of the library complex.

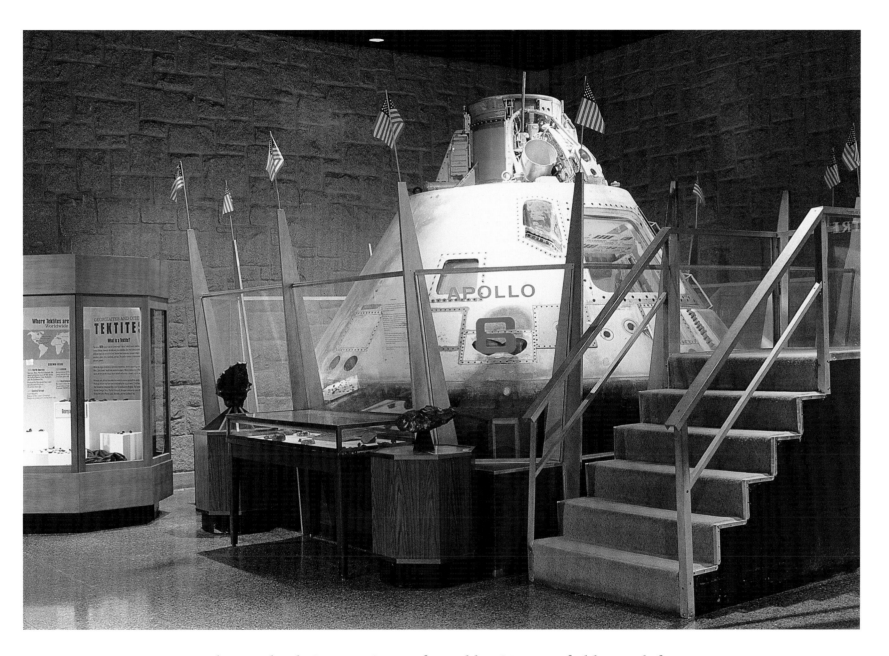

The Fernbank Science Center, framed by 65 acres of old-growth forest, opened in 1967. From America's explorations of space to the prediction of weather and the movements of the earth's crust, the center strives to make science intriguing and accessible to the thousands of students and visitors it attracts each year.

The dinosaur gallery at the Fernbank Museum of Natural History puts time—and size—in perspective. The massive skeletons include winged pterosaurs, a meat-eating gigantosaurus, and the argentinosaurus, the largest dinosaur skeleton ever discovered. Even the floors are part of the display. They include tiny fossils from the Jurassic Period.

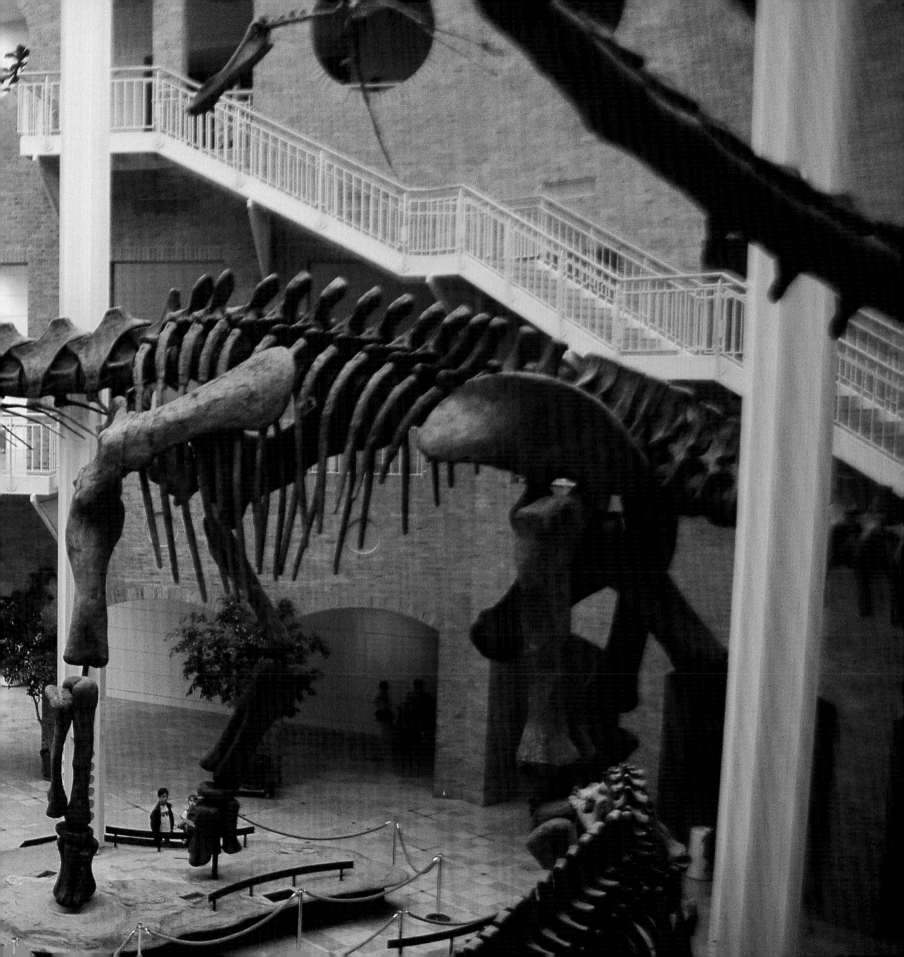

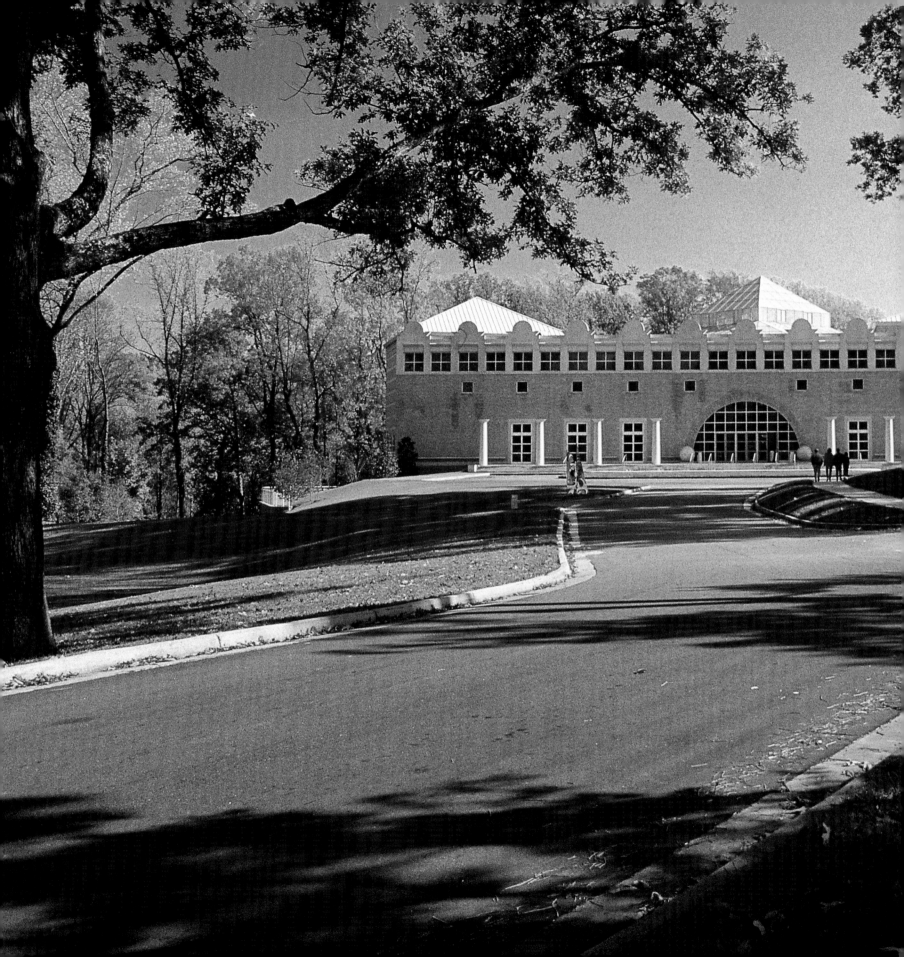

Using Georgia as an example, the Fernbank Museum of Natural History whisks through the ages of the earth and its creatures. Exhibits begin 15 billion years ago with the origins of the universe and lead through the formation of the Okeefenokee Swamp, the birth of coral reefs, and the future effects of global warming and climate change.

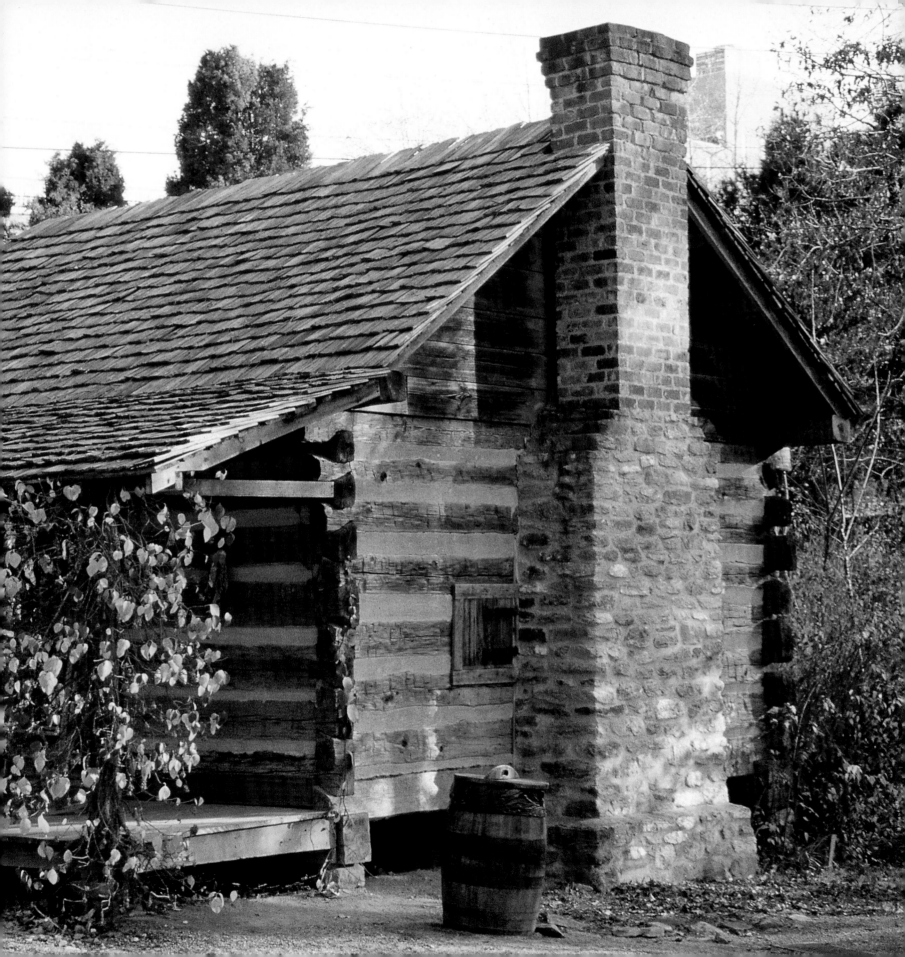

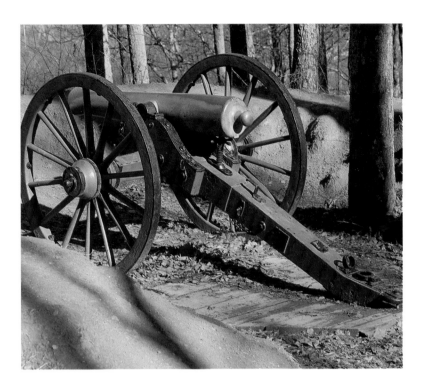

In 1864, Confederate and Union forces clashed in one of the bloodiest battles of the Civil War at what is now Kennesaw Mountain National Battlefield Park. More than 67,000 soldiers were killed, wounded, or captured. The 2,884-acre park is named for a Cherokee word that means "cemetery" or "burial ground."

Atlanta's family farms and plantations once included slave cabins such as this one. In 1830, there were more than 2 million slaves in America, many of them laboring for white plantation owners in the South.

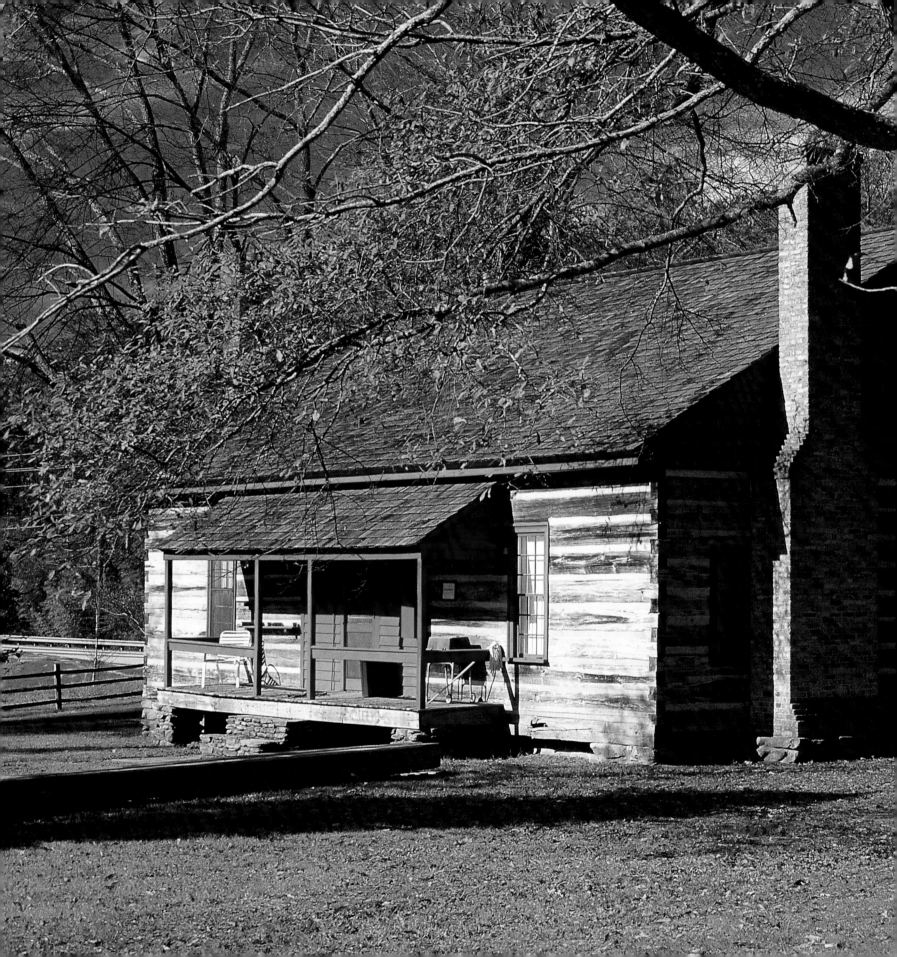

In the decades preceding the Civil War, the Cherokee people who once inhabited this land had been forced west, and small farms and settlements began to appear. As the army of General William T. Sherman pushed toward Atlanta, homesteads such as Kolb's Farm, now preserved by Kennesaw Mountain National Battlefield Park, were often destroyed or appropriated by soldiers.

87

Château Élan Winery and Resort is only a few decades old, but owners Donald and Nancy Panoz modeled the 3,500-acre estate on the architecture and winemaking heritage of France. They added traditional southern hospitality and resort features such as a luxury inn, a spa, an equestrian center, and conference facilities.

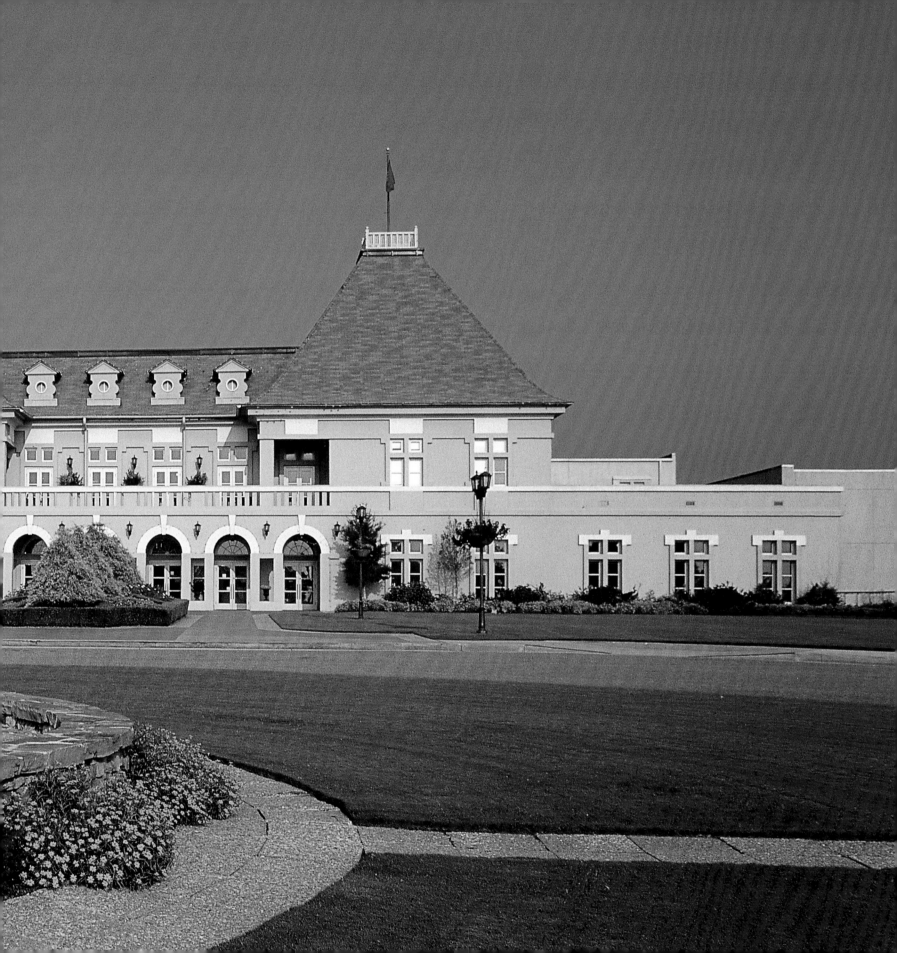

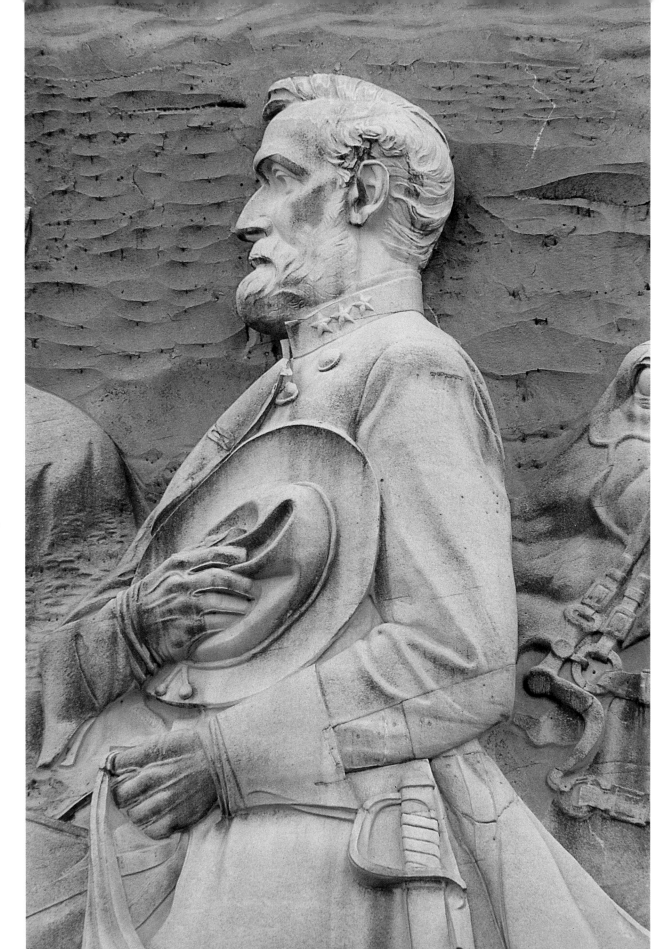

Just 16 miles from down-town Atlanta, Stone Mountain Park is named for a massive uprising of bare granite. Here, over a period of more than 50 years, sculptors carved a relief of President Jefferson Davis, General Robert E. Lee, and General Thomas J. "Stonewall" Jackson. Completed in 1972, the relief is larger than a football field.

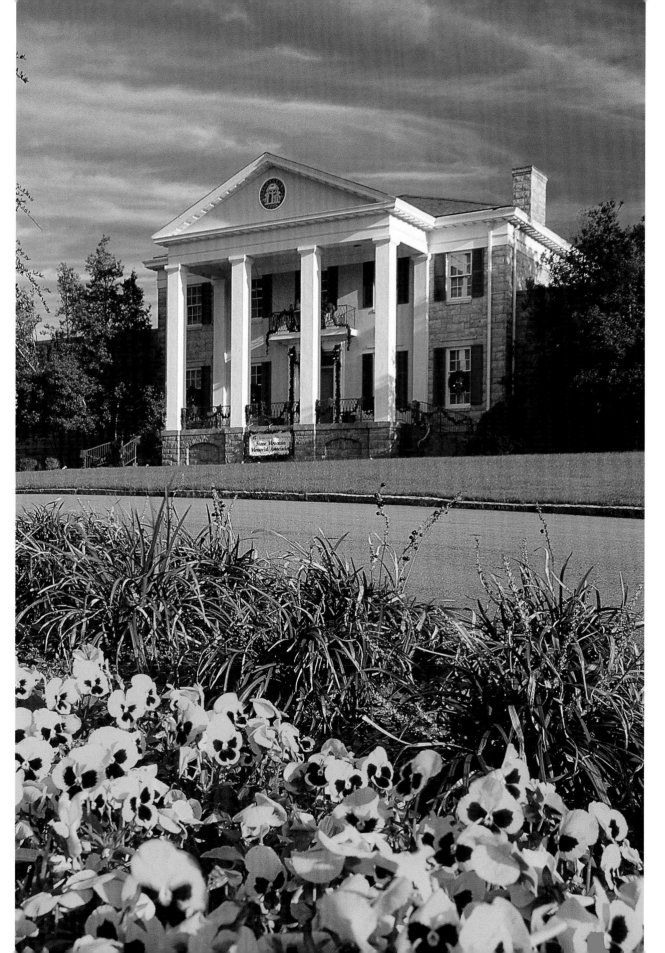

More than 4 million visitors tour Stone Mountain Park each year, both to view the historic attractions and to explore the park's 3,200 acres. Nature trails wind past serene lakes, and woodlands harbor red-tailed hawks, great blue herons, box turtles, deer, and foxes.

OVERLEAF—
The Antebellum Plantation in Stone Mountain Park lets visitors explore an early nineteenth-century settlement. The plantation's authentic buildings include a manor house, a coach house, a plantation office, a smokehouse, and slave cabins, all rescued from sites across the state.

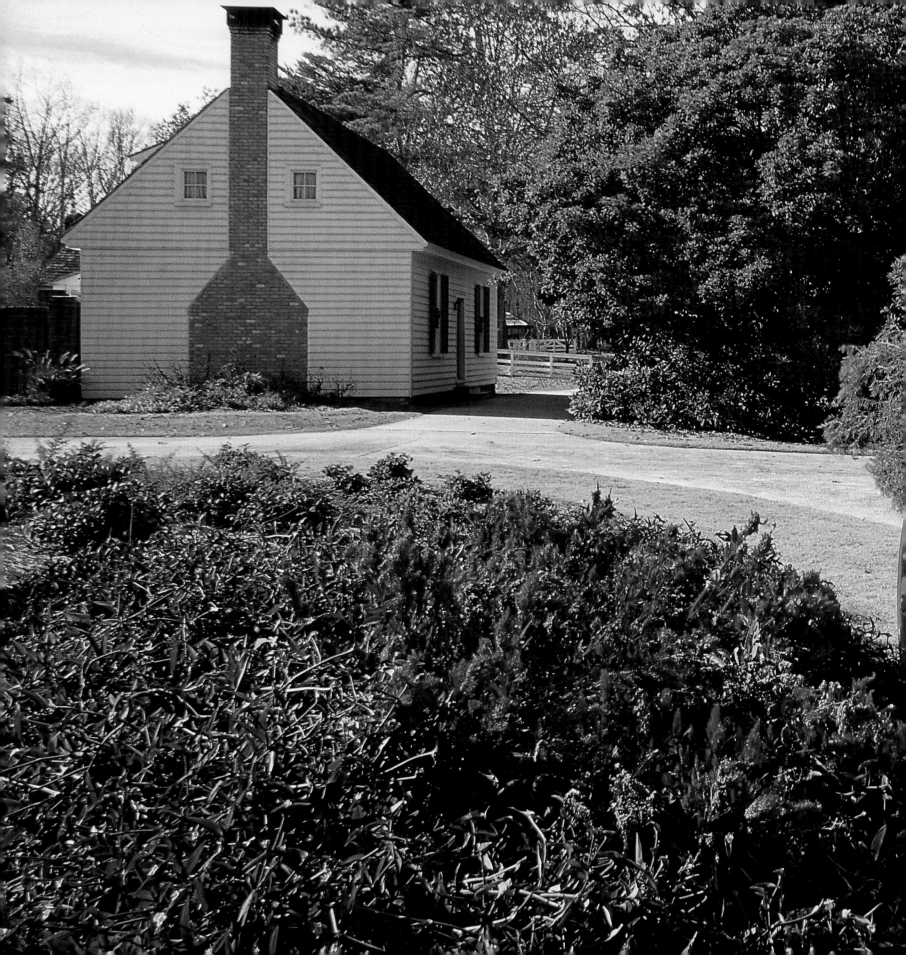

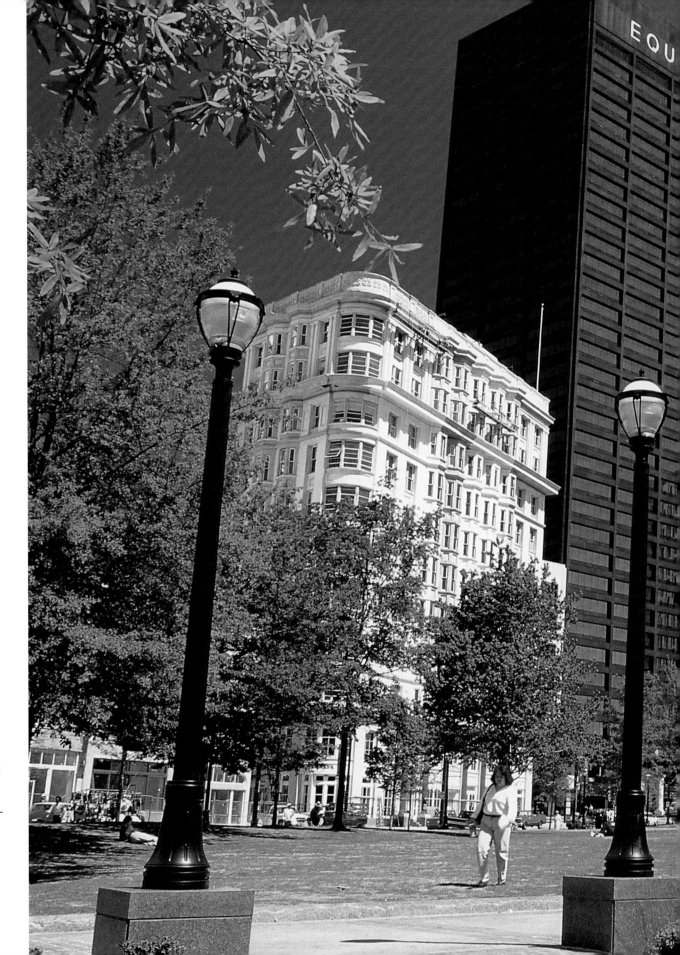

Tourism is not the only booming industry in Atlanta. The city is one of the five fastest growing high-tech centers in America, home to more than 10,000 technology-based companies.

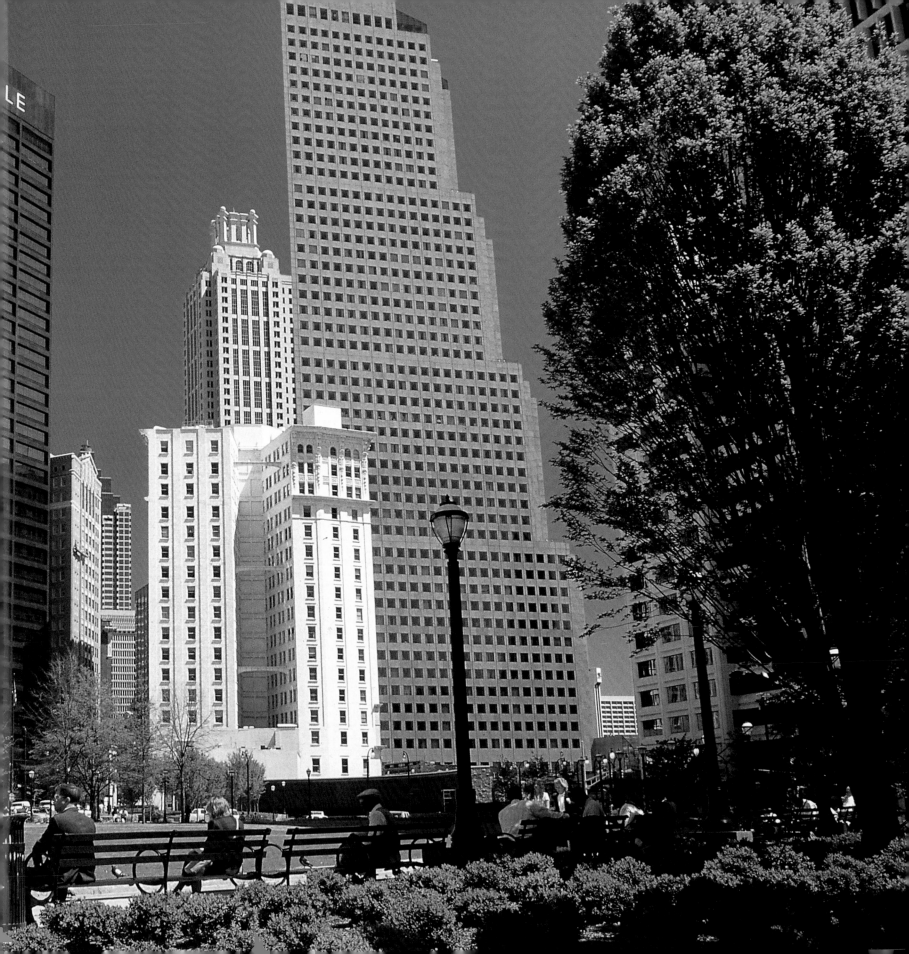